Actors as Artists

Charles E. Tuttle Company, Inc.

Boston, Massachusetts Rutland, Vermont Tokyo, Japan

Actors as Artists

Jim McMullan and Dick Gautier

Published by the Charles E. Tuttle Company, Inc. of Rutland, Vermont & Tokyo, Japan with editorial offices at 77 Central Street, Boston, Masschusetts 02109.

A portion of the profits from this book will be used to support the work of the Permanent Charities Committee of the Entertainment Industries.

Library of Congress Cataloging-in-Publication Data

McMullan, Jim, 1936-
 Actors as artists / Jim McMullan and Dick Gautier.
 p. cm.
 ISBN 0-8048-1783-9
 1. Actors as artists—United States. 2. Art, Modern—20th century—
United States. 3. Actors as artists. 4. Art, Modern—20th century. I. Gautier,
Dick. II. Title.
N6512.M37 1992
704'.7921'09730904—dc20
 92-3790
 CIP

Credits and Acknowledgments

Every effort has been made to obtain appropriate permissions to credit copyright holders. Rights holders who wish to contact the publisher should communicate with the editorial office of the Charles E. Tuttle Company, Inc., 77 Central Street, Boston, MA 02109.

Jacket and text design by Janis Owens

First printing 1992

PRINTED IN HONG KONG

Acknowledgments

We gratefully acknowledge the assistance of the following:

Peter Ackroyd, president of Charles E. Tuttle Company, without whose tireless faith and unquenchable enthusiasm there would have been no *Actors as Artists*.

To a group of exceptionally gifted actors/artists who generously gave of their time and talent and patiently stood by us during the long and checkered climb to the publication of this book. Also to Norman Lear for his insightful and articulate foreword.

To Linda Smith, our delightful editor, who caught the spirit and never flagged; to her talented colleague, Bette Carter; and to the book's designer, Janis Owens.

To Ralph Merlino for his wonderful photographs and infinite patience, Pam Lishin for her confidence in the early days of this project, and to Barbara Stuart for bringing us together. To Danielle Guttman, Lisa Tabor, Lisa Paulsen, and the crew from the Permanent Charities Committee, and to Nick Bosustow for initially helping us to find our publisher.

And to Jack Wilkie and the people from the Franklin Mint, Earl Holliman, Simon S. Waltzman, Dick Guttman, Carolyn Prousky, Lou Zweier, Marva Marrow, Yoram Kahana and his Shooting Stars staff, Steven Beglieter, Bettye Ackerman, Ralph and Alice Bellamy, Helen O'Hagen, Lisa Beery, Ingrid Vanderstok, Alicia Miles, Debbie and Olive Seales, Red 44 Gallery, J. Watson Webb, Jr., Tobey Mostel, Francesca Sanchez, Caleb Mason, Michael Moss and Beth Medway at SAG, Eleanor Philips Colt, Marge Zimmerman, John Appuhn at Curtis Management Group, Shirlee Fonda, Brooke Forsythe, Paul Gregroy, Marita McCarthy, Fred Spektor, Danny Huston, Henry Hyde, Cody Palance, Margaret and Maggi Lindley, Katherine Bevin, Wendy Woolf, Catherine Campion Regehr, Scott Jackson, Shirley Hunt, Shirley Schroer, George Spota, Teruko Williams, Ida Johnson at Brown and Bigelow, Allan Foshko, Madlyn Rhue, Michael Levin, and an army of unnamed agents, managers, secretaries, aides, and assistants who fielded our persistent calls with grace, good humor, and courtesy.

Jim also wishes to thank his wife Helene and his two sons, Sky and Tysun, for their loving support and encouragement.

Contents

Foreword

If my grandmother were alive and I told her I had been asked to write the foreword for an art book, I'm sure she would have looked me over skeptically as she did when I was a boy, reporting this or that achievement to her, and said: "Go know!" That two-syllable expression would have taken a paragraph from anyone else. It meant, "Go explain why someone would expect *anything* from this tentative, uncomfortable, ludicrous child?"

That's the way I approached this task: uncomfortable and tentative, finding it ludicrous that I would be asked to write these words. True, I have been collecting contemporary art since the early 1970s, and I believe most would concede that the Lears have a nice collection. But I have not schooled myself in contemporary art, or any art for that matter. I have never taken the responsibility for understanding what motivated a given artist to execute a specific work; what period in the artist's career it fell into; or how all of that might impact the piece's marketability. I simply like what I like. No, I love what I love.

It was only after I looked at the dozens of samples, with which Messrs. McMullan and Gautier provided me, that I began to see that I might indeed have a perspective on the work in this book. I have known a number of these artists in their other lives as actors. I have worked closely with many, not all, and I was surprised, until I saw their work, that they considered themselves artists on canvas and in sculpture, as well as on the stage and before the camera.

But then, studying their work, growing more and more to appreciate it, I realized that the art you see on these pages is, like acting, a matter of observation, interpretation, and delineation. Acting, generally conceded to be an interpretive art, always begins with the author's original creation, the words. The image that the interpreter with brush and canvas plucks from life and molds to his or her artistic whim—altering, brightening, stylizing, interpreting—also has an author. Different skills, the same essence.

This then is a book that can be enjoyed on many levels: as merely an art book, and it does stand alone in that respect; as a book of artwork by some of your favorite celebrities; as a tool for melting the theatrical masks of these well-known performers to reveal the entirety of the person beneath; and as a lamp that helps us see into the far corners of the artistic temperament.

Voltaire said it first:

All the arts are brothers.
Each one a light unto the other.

Norman Lear

Introduction

The four-year odyssey of preparing this book was like being on a treasure hunt. The search was sweet as we uncovered the art and talked to the artists. As we discovered their creations, each one unique and special, one idea continued to emerge as we discussed the process and reasons for the work; each actor talked about a creative spark that needed to be expressed. Where that spark comes from will always remain a mystery; but that spark, channelled into an artistic energy or a brilliant performance in a play or film, becomes an eternal flame to warm the world. That is what our book is about: the actor, the spark, and the creative expression.

Many actors started out to be artists, cartoonists, architects, or designers and somehow got side-tracked to the world of theater, never to return professionally to their first love. So art became for them an avocation—a spare-time foray into a quiet, peaceful island—the peace and privacy of art a stark contrast to the grueling and wildly disorganized profession of acting. Others discovered art while searching for some diverting and fulfilling pastime to fill the endless hours of waiting that every actor must endure—waiting for the agent to call, waiting for the script to be sent, waiting for the scene to be shot, waiting for someone else to decide what the actor will do.

The actors in this collection could not be satisfied with acting as their only mode of expression. Acting is an interpretive art and a collaborative one, dependent on writers, directors, producers, and publicists. No wonder so many actors paint and sculpt—arts of sole creation. This is direct expression: no committees, no collaboration, no meetings. The artist is writer, producer, and director all in one—a blissful power.

Some of our contributors had to be coaxed into participating in this book, uncertain about the quality of their work as compared to others. But art is not to be compared; it fails or succeeds on its own merits. Performers' bravado can be a cloak donned for the public and for the workplace, but in their contemplative, creative moments, alone with their art, their real personalities emerge. It is this glimpse into the souls of the artists that is so compelling to the viewer of their art.

Jim McMullan
Dick Gautier

Actors as Artists

Bettye Ackerman

I have always been an ardent admirer of art. A friend once remarked that she could get "museum poisoning" from me. When I went to New York City to become an actress the first place I went to was the Museum of Modern Art.

My first drawing was of my husband, Sam Jaffe. One night after dinner, I sketched him on the back of an envelope. How fortunate I was to live with one of the world's greatest models! After years of study and work I'm still trying to capture what one moment of sheer inspiration gave me that night.

The paradox that we're permanently in transition has always excited me. I try, by use of colors and shapes, to express this constant movement.

The discovery that one does not paint with one's hands but through the dictates of the unconscious was singularly freeing for me. Knowing that every time we start to create we must begin all over again, go back to the starting line, is terrifying and thrilling.

I think what really gave me my own voice was the realization that there is great beauty in imperfection.

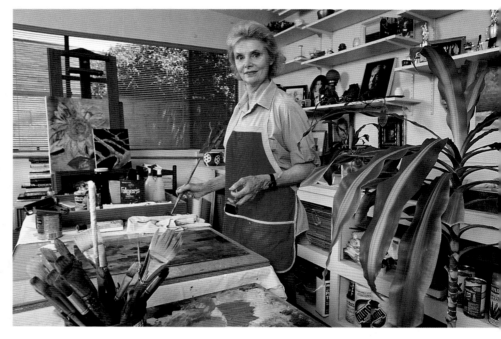

After attending Columbia University and studying acting with Stella Adler, Bettye Ackerman did summer stock, Off Broadway, and live TV. Her greatest thrill was playing Elmire to Sam Jaffe's Tartuffe in the Poetry Series at the Kaufman Auditorium. She and Sam were married, with Zero Mostel as their best man.

In 1960 Bettye and Sam came to Hollywood to co-star, for five years, in the very successful medical series "Ben Casey." Most people remember her as Dr. Maggie Graham. She was a regular on "Return to Peyton Place," and has guest starred on over 400 TV shows including "Dynasty," "St. Elsewhere," "Falcon Crest," and "The Waltons."

Bettye studied art at the Otis Institute in Los Angeles and has had ten one-woman art shows.

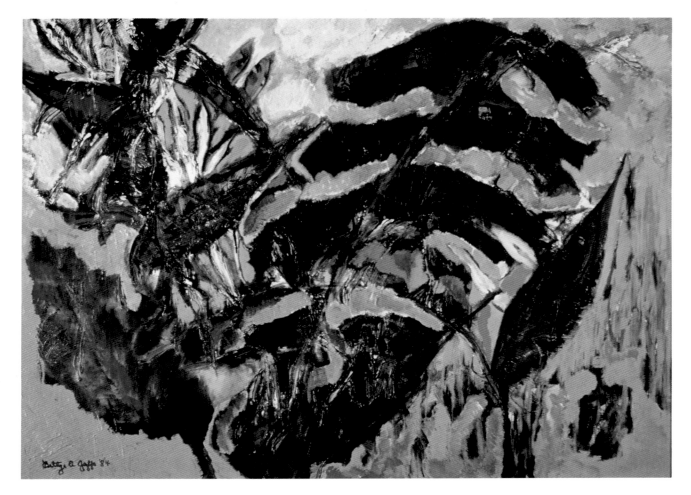

Bird of Paradise Palm, 48" x 36", oil

Steve Allen

The creative gift of any sort, whether it's modest or impressive, is just as much of a surprise to those who do it as to those who watch them paint, read their poems, or whatever it is they do.

The gifts were all there in childhood. The things I do now were all there when I was ten. I was writing little songs, acting in the school plays—that sort of thing.

My bronze bust of Skitch Henderson came about when on the "Tonight Show," a guest, a sculptor, started to give me a lesson. I arbitrarily chose Skitch. I went to the sculptor's studio a few days later armed with some eight by ten photos of Skitch and after five or six days I finished the bust.

I worked all day. I wasn't hungry. I wasn't tired. Time got bent out of shape by the intensity of the creative concentration.

We'd like the world to be simpler than it is. One of the things we've done is to build a connection between gifted people who are total jerks and logic. Out of that came the concept of "the muses."

Versatility does not necessarily mean talent. You can be mediocre in a host of things. You're versatile but not especially talented.

There are three things that'll prompt strangers to talk to you on the street: a baby, a puppy, or an easel. When you are painting, people will inevitably stop and say "very good" or whatever.

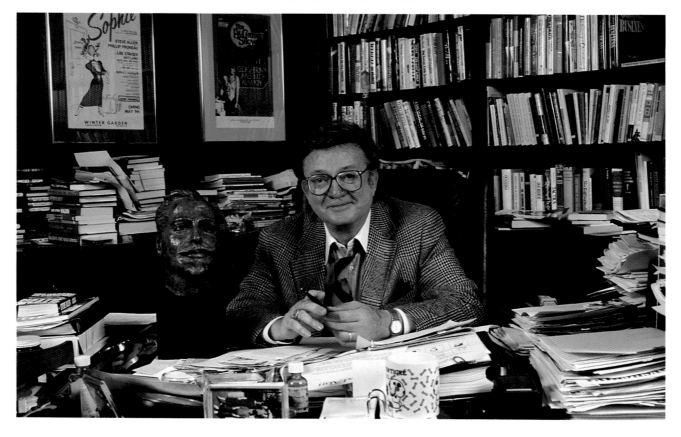

Steve Allen created and hosted "The Tonight Show," has had thirty-six books published, and starred on Broadway in *The Pink Elephant.* He has also starred in motion pictures, notably *The Benny Goodman Story,* written over 4,000 songs including "This Could Be the Start of Something Big" and "Impossible," and written the score for several musicals. He has made over forty record albums, wrote a critically acclaimed play, *The Wake,* and starred in the television series "The Steve Allen Comedy Hour." He created, wrote, and hosted the Emmy award-winning PBS series "Meeting of Minds." Recently he was inducted into the TV Academy's Hall of Fame.

Steve Allen is married to actress/comedienne Jayne Meadows.

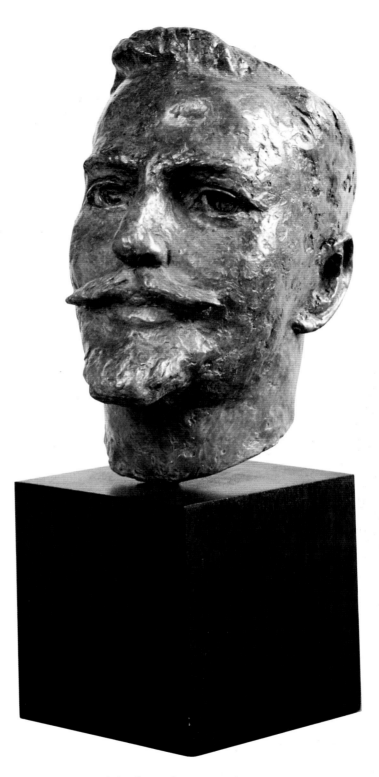

Bust of Skitch Henderson, 12", bronze

Tige Andrews

I was encouraged to start painting by a fellow actor/artist, Ed Eisner, during a production of The Threepenny Opera in New York. I remember doing sketches and portraits with colored makeup and rouges worn by the "ladies of the evening" in the show. I studied for one year with Martin Lubner in California, and painted continuously for twelve years after that.

I'm fascinated by art in all its forms. I realized that it wasn't something that I had to get hired for. I could do my own "lines" at any time. I didn't need a script and other actors.

I think that while painting, one is completely suspended in the moment. The body stops aging for the period of time spent in a studio. This time is added to one's natural life span, hence, barring accidents, intentional or otherwise, painters in general live to ripe old ages.

I believe I'm an impressionist-expressionist with an occasional humorous "pop" extension. I like to work in a whimsical vein. Why does art have to be serious all the time? If I don't get an emotional charge out of it, I stop. Acting, painting, art—it's all the same. I need to be passionately involved.

Once I did a portrait of John Ford. I felt that it captured the mood and I couldn't wait to show it to him. He looked at it for a moment, winked, and nodded his head. I gave it to him. When I came back to his house the next time I looked for it. I didn't see it anywhere so I finally asked where it was. He said, "It's down in the basement with the rest of our prized treasures." I looked at his mantle bedecked with Oscars and other awards. Weren't these treasures? His valet took me to the basement and there in a wire compound covered with sheets were the many artifacts, including my painting. I took it back and hung it in my home.

I started doing lint paintings in 1969. I use lint from my dryer. It's primitive, but I like it. My friends save their lint for me. Black and red are hard to come by. Afterward, I spray them with a deadly substance. I have to work in a mask.

I think an actor should take at least one course in painting before he starts his career. It's like what Balzac said of marriage: "A man should not take a wife until he's studied anatomy and has bisected at least one woman!"

Tige Andrews was born in Brooklyn, New York. He was named Tiger in accordance with an ancient Phoenician superstition that says if a mother gives birth to a child and it dies, then the next child born, if it is sickly, should be named after a strong wild animal. Tige was sickly at birth, so his Syrian grandmother convinced his father to call him Tiger. He attended school in New Jersey, planning to study medicine. World War II interrupted his education.

After the war he returned to school and was graduated from the American Academy of Dramatic Arts. Director John Ford brought Tige to California. He has appeared in many films and television productions including the TV series "Mod Squad," for which he was nominated for an Emmy for his role as Captain Adam Greer. He has also appeared on Broadway in Mr. Roberts and played Mack the Knife in the original production of The Threepenny Opera.

He is married to former ballerina Norma Thornton and they have six children.

Calabasas, 33" x 33", lint

Michael Ansara

Looking at a white, blank canvas is the equivalent to me of the opening night performance of a play. It is frightening! Where do I go from here? Is it going to turn out all right?

Believe it or not that is what I always go through when I start a painting. Very scary! As in acting, some paintings turn out all right, some mediocre, and a few very satisfactory or very good. Some I throw away or paint over the canvas with another subject.

I hate some paintings when I do them but over a period of time they grow on me. I learn to like them very much. Sometimes learning to like them takes days, months, or even years.

I always go back and look closely at the paintings I keep. I study them closely, remembering every stroke with a great deal of pleasure and satisfaction.

Sometimes I remember a painting I have done and given away years before because I didn't like it. One of them is called Skull. I rediscovered it and fell in love with it. This one turned up in my cousin's house in Lowell, Massachusetts, in a dusty storage room. He gave it to me because he didn't want it. How he got it in the first place I don't know.

Charlie Bronson started me painting years ago. I thought I had no interest in it until I watched him paint. One day he put a brush in my hand and away I went. I was hooked forever. I studied for a while with Sergei Bongart.

I love painting almost more than acting. Now that I'm older I think I love painting more.

I haven't painted for a long time but I know I soon will and I'll submerge myself wholly in it for the rest of my life.

Michael Ansara attended Los Angeles City College, where he was preparing for a medical career. In an attempt to overcome his shyness, Michael added a few theater arts classes to his curriculum and discovered that the theater held a tremendous fascination for him. After leaving LACC, he enrolled at the Pasadena Playhouse.

Michael's big break came through a playhouse production of *Monsterrat*. An agent from Warner Brothers saw his performance and Michael found himself playing in *Only the Valiant*. Picture followed picture with Michael playing the villain. Michael's "heavy" image proceeded unchanged until he won a major role in the "Bro-ken Arrow" TV series playing Apache chief Cochise. For the first time in his career, he was the "hero." Many film, television, and stage roles followed.

Michael is married to actress Beverly Kushida and is the father of a teenage son, Matthew. They reside in Calabasas Park, California.

Skull, 28" x 16" , oil

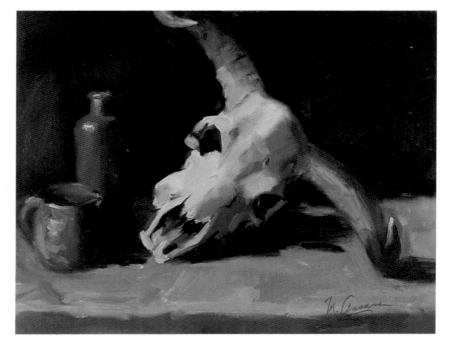

Renaissance Man, 14" x 18", oil

Lew Ayres

In my life, I have tried to learn something about all artistic presentations—not just paintings. I did all the conventional pieces—landscapes, still lifes, etc. My work was never outstanding.

Right after World War II I went to art school by mistake. A friend of mine bought all the equipment—easels, canvasses—but then he lost interest. He met a girl. He got the girl. I got the art lessons.

Ultimately I began to want to express myself. I felt I wanted to say what was inside of me—my thoughts, my thinking, my philosophy, my ideology.

My study of comparative religions began in 1954 when I was well into art, but it was some time before these elements began to fuse—art and philosophy.

I'm handy. I do a little plumbing, a little carpentry, so the evolution into art and wood was a natural one for me.

Any expression of art is an uncertain, hesitant one. I like it. I'm a fanatic. I must finish what I begin. It takes me about six weeks to finish one of my wooden pieces.

My philosophical attitude is that man is truly free. God has given us a true freedom. It's an exciting kind of thing. I see God sharing in the desire for man's freedom. His eye is on the sparrow but his hand is not reaching out to break its fall.

I wouldn't presume that I'm an instrument of a Godlike force. I don't have that kind of ego. I'm a mirror, a craftsman. There is no divine intervention when I work.

I try to do things as an actor and as an artist that mean something. But you have to take the chips the way they fall.

I was never a star. To me a star is someone billed above the title. I was a journeyman actor. Somehow I've managed to hang in there. I'm a professional.

The spectrum of human life is quite wide in the acting world so we can work through all of our ages.

I've had offers for one-man shows but I hate to take my paintings down. They're heavy. And I miss them. They represent a lot of work.

Actors are not artists. Actors have a leaning toward art and we have the time available to us. We have the freedom to use the time as we wish. Combined with the inclination, that sometimes produces art.

Dilemma of a Non-Intrusive God, 36" x 48", wood relief

Lew Ayres came to Hollywood in 1920, was discovered by the late Ivan Kahn, and signed a contract with Pathé Studios in 1929. His contract was dropped after six months. He was then signed by producer Paul Bern for a juvenile lead opposite Greta Garbo in her last silent film, *The Kiss*. In the autumn of 1929 he won the lead in *All Quiet on the Western Front*. This paved the way for a fifty-year career in motion pictures. In the 1930s he played the original Dr. Kildare in the film series, and later he appeared in *The Dark Mirror*, *Johnny Belinda*, *The Unfaithful*, and *Donovan's Brain*. He also did the radio series of Dr. Kildare. He has appeared in numerous TV productions and, in recent years, in films such as *Advise and Consent* and *The Carpetbaggers*.

In 1964, having been divorced for twenty-five years, he married his present wife, Diana, a British subject. They live in Hollywood with their son, Justin Bret.

I didn't want to act. I wanted to paint or draw. I was related to the theatre by marriage only. I compromised by deciding I would design scenery for the stage.

Question: How do you learn to swallow swords, sir? Answer: You swallow a sword. If you live, you are a sword swallower. I think that is about the size of most things that people accomplish, excluding perhaps embalming and bookkeeping, which may be arts for all I know. An artist of any kind becomes an artist by trying it and surviving.

I painted copiously, if not industriously, and colorfully, if not successfully. This is what I wanted. The only thing that prevented my becoming a good painter was sheer lack of talent.

My hopes of becoming an artist evaporated but I perceived that unless I could grasp a brush in my hand quickly, I would have to succumb again to the family trade of acting.

I have been asked, whatever became of all the pictures I painted? After all, in something more than three years a man gets a lot of paint on canvas, good or bad. I most certainly used up a vast amount of paint but I never finished anything. In short, I cannot recall that anyone said one kind word about my painting in Paris. It consoles me, though, to recall that I never heard any kind words about anybody else's art either.

For my own part I did not follow any particular school or worship at the feet of any particular master's easel nor do I think I do now. It goes without saying, however, that we are all of us today in a sense impressionists, at least influenced consciously or unconsciously by impressionistic art.

It was not remarkable that they did not hail me as a genius with a paint brush. I left Paris with no idea whatsoever how good I might be but I privately suspected that I was no Rembrandt.

Lionel Barrymore

Lionel Barrymore was born in 1878 into one of America's most distinguished theatrical families. He spent the rest of his life developing his talents until he died in 1954. Most of his career was devoted to films but, as with many actors, his beginnings were in the legitimate theater along with his brother John and his sister Ethel.

From the early 1930s, he acted and directed. He became a member of that rare galaxy of performers—the MGM stock company. In 1938, two falls and arthritis caused him to spend his remaining years in a wheelchair but he managed to continue his career until the end of his life. Among his best-known films are *Sadie Thompson, Grand Hotel, Rasputin and the Empress, Ah, Wilderness, Captains Courageous, Test Pilot, You Can't Take It with You,* the entire series of Dr. Kildare films (with Lew Ayres), *It's a Wonderful Life,* and *Key Largo.* He also wrote an autobiography titled *We Barrymores* and a novel, *Mr. Cantonwine, A Moral Tale.* The advent of the boom, or mobile microphone, is attributed to him, an idea born out of necessity and frustration while he was directing an early talkie.

Nantucket, 12" x 14", etching

Noah Beery

I basically work in wax—mostly Western subjects and natural history. I use the lost-wax process to turn them into bronzes.

I didn't do bronzes until around 1930. I'm from New York. We moved to Hollywood when I was just a kid. My dad went to work at Paramount Studios. I became interested in horses when I started acting. I did lots of westerns.

I'm completely adamant on the posture; it has to sustain itself. I like to keep my art completely separate from my TV work. In my mind, they don't belong with each other.

I admire the work of Charlie Russell. His bronzes are what inspired me to start sculpting. I used to pick up sketches from his wastebasket.

I feel a great affinity with animals. I can sit and watch them move for hours at a time. When I get inspired, I pick up the wax and lose myself in the process. Often I have no idea where it came from. It's like some outside force helped me do it.

Born into show business, the son of Noah Beery and nephew of Wallace Beery, Noah started as a child actor and has continued to work in a variety of media up to the present. Some of his films are *The Mark of Zorro*, *The Road Back*, *Only Angels Have Wings*, *Of Mice and Men*, *Red River*, *Inherit the Wind*, *The Seven Faces of Dr. Lao*, *Little Fauss and Big Halsy*, *Walking Tall*, and *The Best Little Whorehouse in Texas*.

He became a mainstay in television in such series as "Circus Boy," "Custer," "Doc Elliott," and "The Rockford Files," in which he played James Garner's bumbling but well-meaning father.

Noah and his wife Lisa divide their time between a ranch outside of Los Angeles and their Malibu beach house.

Jauquin's Last Kiss, 8" x 8", bronze

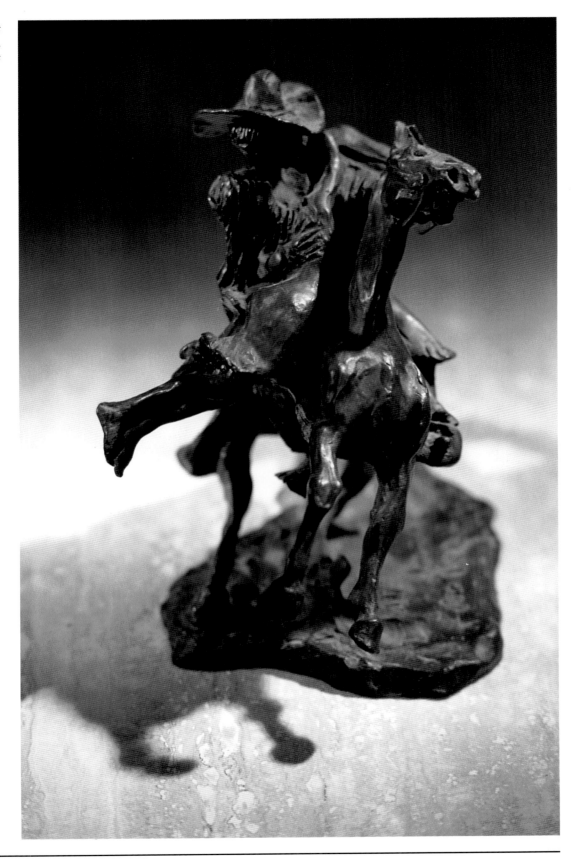

Ralph Bellamy

It's very interesting to me that so many actors are interested in art. I don't know why so many of them find pleasure in it. I do know that I just have to do it.

I've been influenced by all the classical artists and their use of color. It's hard for me to select one artist. I like so many of them. I studied with Sergei Bongart, a wonderful Russian artist and painter. I introduced Gene Hackman to him years ago.

When I do a painting it seems to clear me out. All the mental cobwebs are lifted. I suppose this is true for any form of self-expression. It's a kind of catharsis, a release from all of one's mundane problems and pains. Whenever I create anything, be it in art or in acting, I always feel lighter and freer when I'm done. It's the creation that's important. We all have that creative spark and each of us uses different tools to express it.

Ralph Bellamy was born in 1904 and died in 1991. For seven years he appeared in plays all over the U.S. until 1929, when he made his Broadway debut in *Town Boy*, which opened on a Friday night and closed after the Saturday matinee! His next Broadway play, *Roadside*, didn't last much longer—two weeks—but it resulted in four motion picture contract offers.

His first Hollywood movie was *The Secret Six*, which starred Clark Gable, Jean Harlow, Lewis Stone, and Johnny Mack Brown. From 1930, the year he made *The Secret Six*, until 1988, he made 105 motion pictures. Among them are *The Virginian*, *Rebecca of Sunnybrook Farm*, *Hands across the Table*, *The Awful Truth*, *His Girl Friday*, the Ellery Queen series, *Sunrise at Campobello*, and *Rosemary's Baby*. He has appeared in numerous radio and television shows.

Among his many honors are an Academy Award for *The Awful Truth* in 1937, the Academy of Radio and TV Arts and Science's Best Dramatic Actor award in 1950, a Tony Award for his role as Franklin Roosevelt in *Sunrise at Campobello*, and an Emmy for a documentary titled *One Reach One*. The Screen Actors Guild (of which he is a founding member) and the Academy of Motion Picture Arts and Sciences have given him humanitarian awards.

Ralph Bellamy married Alice Murphy in 1949.

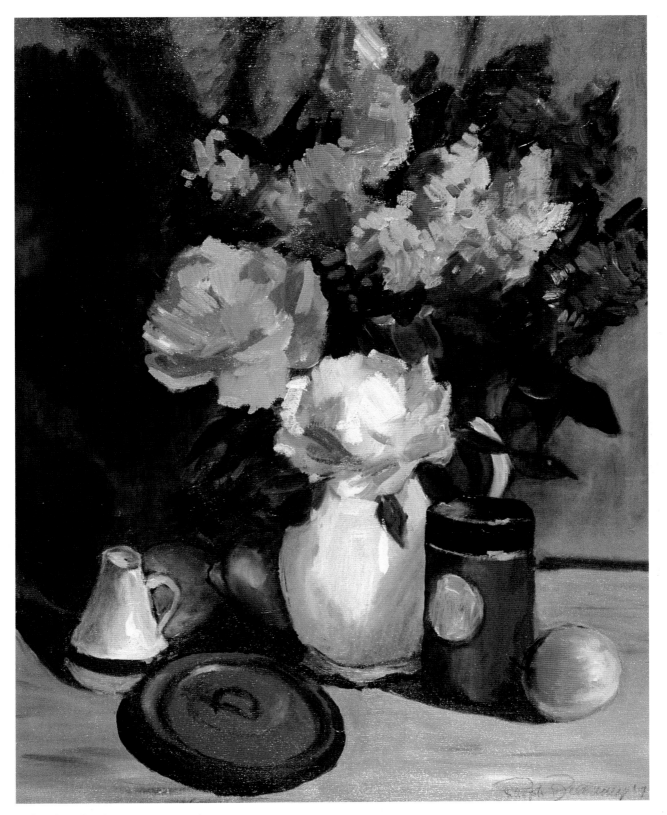

Still Life with Lilacs, 18" x 24", oil

I scarcely consider myself a serious artist, even though I studied art at the University of Pennsylvania. I do a lot of whimsical things because in some ways I really am pretty whimsical. I'm not a serious painter but I do love it. I get a lot of pleasure out of making my weird compositions with butterflies and bumblebees zooming about all over the place. I try to keep an individual approach to it.

My friends have snapped up all of my paintings, even some oils I did of a couple of hamburgers last year.

Candice Bergen

While in college Candice Bergen commuted to New York for modeling assignments and made her first motion picture, *The Group*. Her other films include *The Sand Pebbles*, *The Magus*, and *Oliver's Story*.

When she is not acting, Candice pursues her interests in writing and photography. She has written many articles for magazines, many of them accompanied by her photographs. Among them are a cover story for *New York* magazine, an article about her trip to China for *Playboy*, and for *Life* magazine, the cover story on Charles Chaplin's return to the United States.

She is currently appearing in the highly popular TV comedy series "Murphy Brown," for which she has won two Emmy awards and a Golden Globe award. In addition to "Murphy Brown," Candice's other TV credits include *Mayflower Madam* and *Hollywood Wives*.

In 1985 she gave birth to her first child, Chloe. She is married to film director Louis Malle.

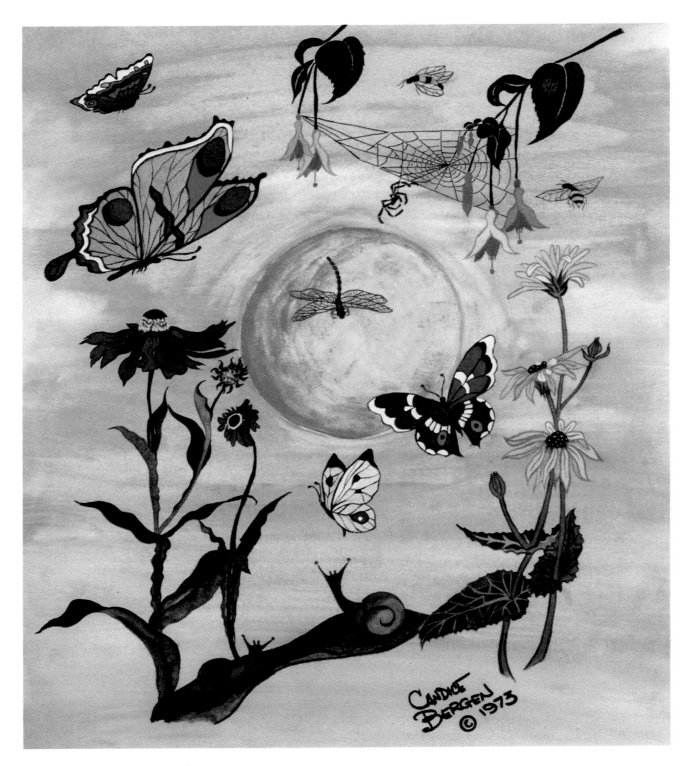

Butterflies, 22" x 28", watercolor

Richard Beymer

It has something to do with not doing anything, getting out of the way, letting "IT" take over, whatever "IT" is. Then, just taking the ride, serving the flow.

My process, my approach to what I do? A character in the screenplay I'm writing, I think, says it. He's talking about writing, but it could just as well be about painting or sculpture. "It's the same process," he says. "This isn't so much the work of a writer as it is a collector. I go up and down the alleys of my mind and others', rummaging through whatever is thrown out, recycling dreams, thoughts, fantasies, doodles, other people's good ideas, overheard conversations, and whatever else I can salvage from the psychic dumpster. In reality I am a junk collector with an eye for thrown out, discarded, assumed useless things that I might rearrange into meanings not of their original intention, but of my alienated POINT OF VIEW." I see my stuff as "recycled art."

Untitled, 37" x 30", found objects

"I came to Hollywood with dreams of stardom in the 1950s and snagged a few major films: *Indiscretions of an American Wife, So Big, West Side Story, The Longest Day, The Stripper*, and *The Diary of Anne Frank*. I rode high on these films until the bottom fell out and I went into the crapper with a thousand other nameless, self-obssessed dysfunctional ego maniacs who pass through this celluliod shit hole.

Soon I couldn't get a job. Even my agent wouldn't answer my calls. Years went by. I ended up in New York in a one-room dive on the lower east side painting self portraits on endless acid trips. By now Hollywood was light years away. I was a bona fide has-been. I was only a memory in one of those "What Ever Happened To?" books and my name showed up in "Trivial Pursuit." I spent my days studying the origin of the universe, following unsuspecting people on the streets with my video camera, and spending what was left of my money having phone sex with a famous Hungarian countess recently widowed living in England.

More and more I lost it. The distinction between dreaming, waking, sex, and the movies became less and less clear. The clearer I'm not who I appear to be got clearer. It's at this point I decided to pursue a spiritual life and become a pin setter in a bowling alley where, thirty years later, David Lynch "spotted" me and resurrected me as Ben Horn in "Twin Peaks." Now extremely wealthy and bored, I live in Beverly Hills where I spend my days serving milk and cookies to passing Hollywood tour buses. Dreams can come true."

David Bowie

David Bowie, singer, songwriter, actor, born London 1947.

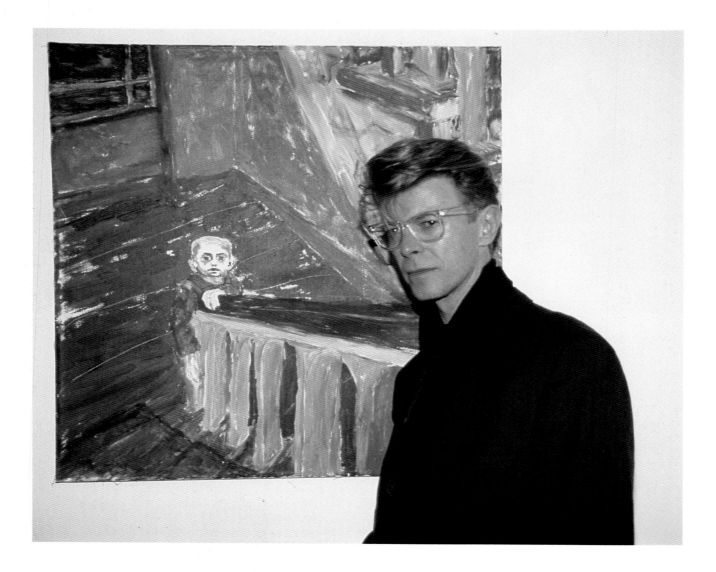

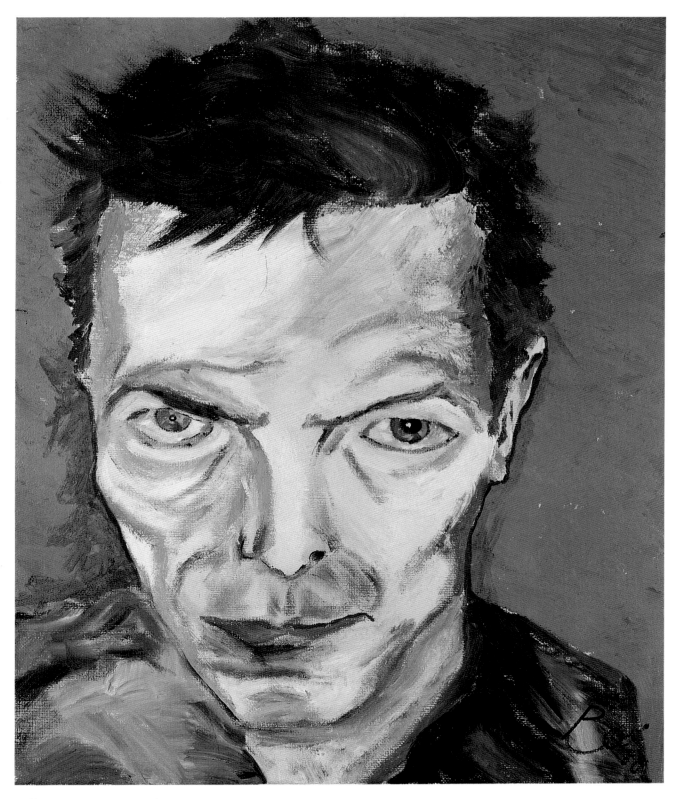

Self Portrait, 16" x 20", oil

Boy in Berlin, 20" x 20", acrylic

Man with Box, acrylic

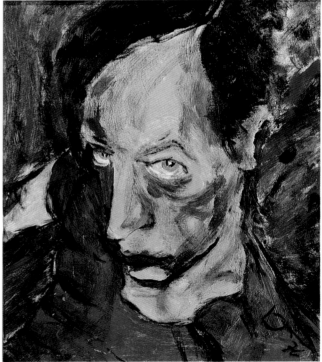

Jim Osterberg, 16" x 20", acrylic

Pierce Brosnan

I never went to art school. I was self taught. I did line and wash drawings for Harrod's department store. I thought art was my destiny until a fellow office mate suggested that I come with him to a theater club. It was 1968, at the height of experimental theater in London—La Mama, the Black Panther movement, musicians, artists. It was an arts lab. That's where I began to blossom, where I began to develop my sensitivity towards imagery, composition, acting, and music. That's when I decided to become an actor.

I really started getting into painting several years ago because of my wife Cassie's illness. One night I was pretty low in spirit and I just got the canvas out and started painting with my fingers. I tried to put down on the canvas the anger and frustration I felt. I just let it rip and put everything into it. I still have that first painting. It's called First Visit. *I used that painting as a prop in a film I just completed called* The Lawnmower Man.

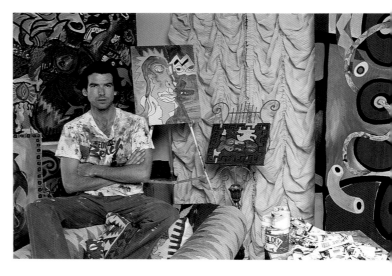

After that first catharsis on canvas, I started to get more control by painting shapes. I have always loved the work of Matisse. I just went with the colors that excited me. I started to educate myself about painting and painters like Matisse and Picasso. I devoured everything I could find on them. My art is in its infancy now and I feel that it's with me for life. Wherever I go I'll always have an easel or a room set aside for painting. I'm educating myself as I go. Do I have a philosophy? No, not yet.

In relation to acting, art has given me more patience. It has balanced out the acting and taken the onus off it. Before, everything was for the acting. That was the only talent I had, I felt. Now I realize that I have a talent to make pictures and to create another world. It's so liberating. I'll always have my painting.

I want to see what it feels like to see my work in a book. I don't care whether someone likes my painting or not. But acting, that's something else. You want to be liked, you want to be good. With painting, if you like it, great; if you don't, that's fine. The privacy of painting, the worlds that you escape to, the things you resolve within yourself—it's so special, so liberating.

Pierce Brosnan's first job in the theater was as an acting assistant stage manager at the York Theater Royal. Six months later, Tennessee Williams selected him to create the role of McCabe in the British premiere of *The Red Devil Battery Sign.* Brosnan went on to star in other London stage productions such as Zeffirelli's *Filumena* and *Wait Until Dark.*

His first American appearance was in the TV mini-series "The Manions of America." He was then cast in his most famous role—the star of the long-running TV series, "Remington Steele." He has also appeared in such TV mini-series as "Noble House" and "Around the World in Eighty Days."

Brosnan was married to the late actress Cassandra Harris (d. December 28, 1991). He has three children and lives in Malibu, California, and Wimbleton, England. He paints whenever he can find the time.

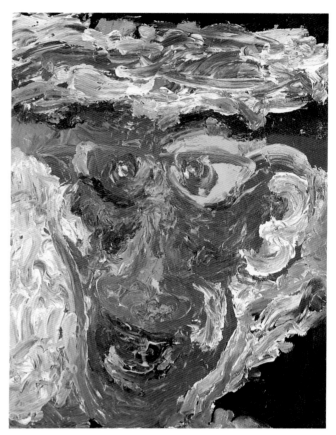

First Visit, 18" x 24", acrylic

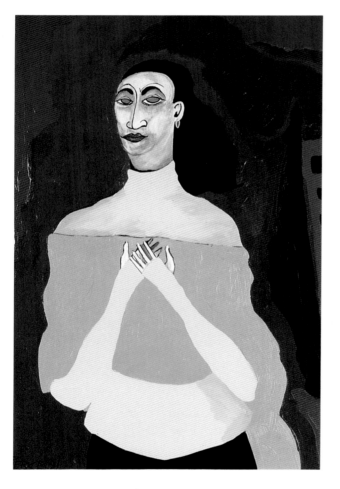

Beirut, 24" x 36", acrylic

I always wanted to be an artist. I do these odd jobs now and then. Sometimes they turn out all right, sometimes they turn out lousy. Art— that's the only thing I started out to do that I didn't finish.

I rarely sign my paintings and accept no money for my work. How could I face those really good artists who have given their whole lives to it and still may be having a tough time making a living? It's just not right. I'm just a novice with some name value.

I have always appreciated art. Whether I could create it or not is open to question. I can recall in my preschool years copying out of the newspapers, just drawing pictures of shoes and clothing and people.

Over the years I've done caricatures of my friends. When I toured the Army hospitals in Europe during the war, I would do caricatures of the wounded kids in their plaster casts in the hope that it would momentarily amuse them.

I have heard many definitions of art but Professor Hecking's seems to me the best. "Art," he says, "is life plus caprice." Caprice, of course, is an indefinable thing, summoned whence no one knows, creating its own kind of tensions.

Patricia Steinke, a fine painter, wrote kiddingly of her feelings when facing a virgin canvas:

> Whenever I see a canvas stretch-ed
> It makes me feel, oh, so wretched!

I wrote her back:

> You felt what others were made to feel:
> Rembrandt, Homer, and Charley Peale
> When they face the pallid, tortured tightness
> A need to impose a devised brightness
> That need strong part of the artist's store
> To create a life where there was none before.

James Cagney

In motion pictures, James Cagney was both a confident song-and-dance man and the definitive movie gangster.

The film that first brought him to the public's attention was *Public Enemy*. Among his other well-known movies are *Footlight Parade, G-Men, Angels with Dirty Faces, The Roaring Twenties, 13 Rue Madeline, The Time of Your Life, Love Me or Leave Me, Mr. Roberts, Man of a Thousand Faces*, and *Ragtime*. Despite all his roles as gangsters, it was for his portrayal of George M. Cohan in *Yankee Doodle Dandy* that he won an Academy Award.

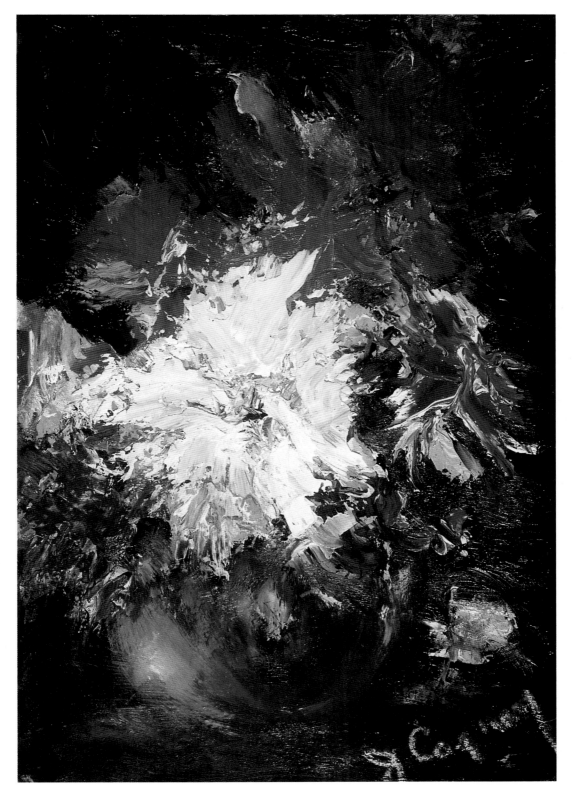

Flowers, 10" x 14", oil

Barbara Carrera

I don't plan my work. I get an idea and then I start. I'd go crazy waiting to get inspired. Something else takes over, something starts to emerge.

These paintings of mine, they're sort of developing on their own. They look sort of cosmic to me.

There is an affinity I have with the shell that I don't understand. I'm not sure what it is exactly but it's very inspiring.

Of all the features, I think that the eye is the most fascinating. In one of my paintings I use the eye as the eternal witness. It's as old as the shell.

I think one eventually will come to that awareness that once one was that shell. It expresses itself through our eyes unconsciously—that we were and are everything.

We really are the world and the world is within us. As an artist and an actress, one of the great frustrations I have with this industry is that it expends tremendous energy to create films that show the faults of man. It rarely takes the time to show man's greatness. What a pity. No wonder our planet is sort of falling apart. Out of that frustration, that awareness, comes these paintings. That eternal witness, the eye that views this whole cosmic joke, is chuckling.

I can't see a difference between art and acting. It's all a creative process. It's just a matter of allowing oneself to be in tune. They're all extensions of the self. We seem to be infatuated with duality. We like to separate. One can do it as an amusement but that's all it should be. If you get caught in it you get addicted.

It's all gifts. It's not an accident. It's having done it in past lives. It merely manifests itself in this life.

Actors, like everybody else, need an outlet. They need their work, their seva. One needs to be creative. One doesn't get that opportunity today in acting.

Barbara Carrera was born in Nicaragua and raised in Europe and the United States.

Modeling was her first career. Her transition from modeling to acting came in the 1975 film *The Master Gunfighter*.

Since that film she has worked with actors such as Peter O'Toole, Burt Lancaster, Laurence Olivier, Sean Connery, and Richard Burton. One of her favorite roles was Fatima Blush, James Bond's nemesis in *Never Say Never Again*. Other films include *Emma—Queen of the South Seas*, *Wicked Stepmother*, with Bette Davis, and *The Favorite*, opposite F. Murray Abraham. She has also appeared on television in "Dallas," "Masada," and "Centennial."

Ms. Carrera calls her paintings "works in progress." She devotes much of her time to painting and playing classical music, all of which represents her personal spiritual quest, evident in her passion for meditation and Syda Yoga.

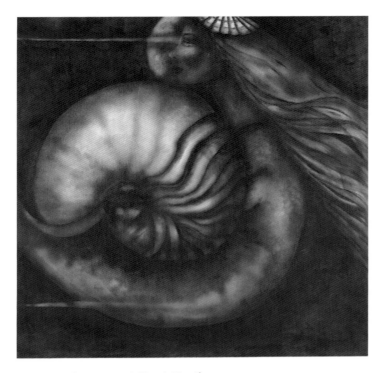

Metamorphosis (#5), 36" x 36", oil

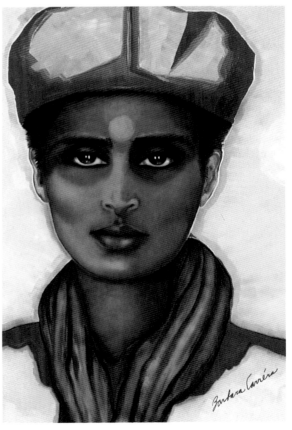

Blue Goddess, 24" x 36", oil

Robert Clary

I am a photo realist painter. I love to do very complicated subjects. It takes great patience and lots of time and discipline. I'm challenging myself constantly, which keeps the painting projects interesting.

I started to paint at a very early age. I went to art school for two years in the early 1940s in Paris. I was as happy about painting as I was about entertaining and I still am.

The Impressionists are still my favorite painters.

I paint with Prismacolor pencils. I say "paint" because I use the pencils the same way I would use oil or watercolor.

I derive great pleasure doing what I'm doing, great satisfaction.

I started to take myself seriously about painting when I was filming "Hogan's Heroes." I had idle time on my hands. I started to doodle on paper and showed what I did to Kaye Ballard, who encouraged me to do it more than casually. Thank you, Kaye.

It's always very rewarding when people appreciate your finished product. A lot of times when I look at what I have done I can't believe that I did them. Without false modesty, I am very proud of my work.

Robert Clary was born Robert Widerman in Paris, France, March 1, 1926, the youngest of fourteen children. He started in show business at the age of twelve, singing throughout Paris. In 1948 a song he recorded, "Put Your Shoes on Lucy," became a big hit in the United States, selling over a quarter of a million copies.

In the theater, he appeared on Broadway in *New Faces of 1952* and, among others, *La Plume de Ma Tante, Irma La Douce,* and *Cabaret.* His first motion picture was *Ten Tall Men,* followed by *Thief of Damascus, A New Kind of Love,* and *The Hindenburg.* He has performed in night clubs throughout the country. On television he appeared on "The Colgate Comedy Hour," "The Young and the Restless," "Days of Our Lives," and for six years played Louis Lebeau on the comedy series "Hogan's Heroes."

Recently, Mr. Clary, as a survivor of the Holocaust, has lectured at high schools, colleges, synagogues, and civic groups throughout the country about the Holocaust.

Mr. Clary has been married for many years to the former Natalie Cantor, daughter of Eddie Cantor. They live in Beverly Hills, California.

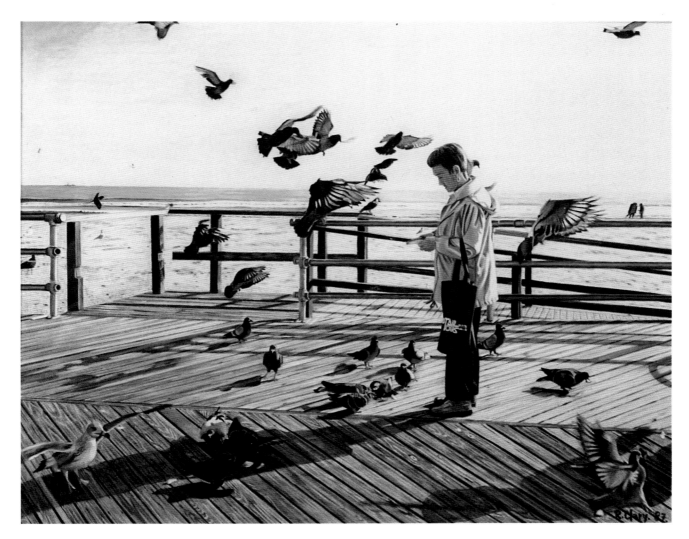

Windy Day in Atlantic City, 20" x 16", prismacolor

Claudette Colbert

I didn't start painting until after I became an actress. Originally I wanted to be a costume designer. That's what I studied for but, by the grace of God, I ended up on the stage. I didn't expect that.

My mother told me that when I was very young, I was always drawing faces with chalk on the sidewalk in Central Park. Portraits are the best work I've done.

My philosophy on painting? Amateur painters don't have philosophies and I don't think professional painters have philosophies. I think you paint because you love it and you're either good or you're bad. These days when artists are painting all those crazy things, impressionism seems terribly old fashioned. If I'm anything, I'm an impressionist. If I'd had a career in art, I think I would have been a portrait painter.

Born in Paris as Lily Chauchoin on September 13, 1903, Claudette Colbert came to the United States as a child. Her first part in a play was in 1923 in *Sibly Blake in the Wild Wescotts.*

Her motion picture debut came in 1929 in a film titled *The Lady Lies.* Many movies followed including *Cleopatra, Sign of the Cross, It Happened One Night, The Palm Beach Story, Since You Went Away,* and *Imitation of Life.*

On Broadway she has starred in *The Marriage Go Round, The Irregular Verb to Love, The Kingfisher,* and *Aren't We All,* among others.

Ms. Colbert won an Oscar for Best Actress for *It Happened One Night,* the Sarah Siddons award for Best Actress in Chicago in 1981, a Lincoln Center Award in 1984, a Golden Globe in 1987 for her performance in the TV movie *The Two Mrs. Grenvilles,* the Officer of Legions of Honor award in France in 1988, and a Lifetime Achievement Award given to her at the Kennedy Center for the Performing Arts in 1989.

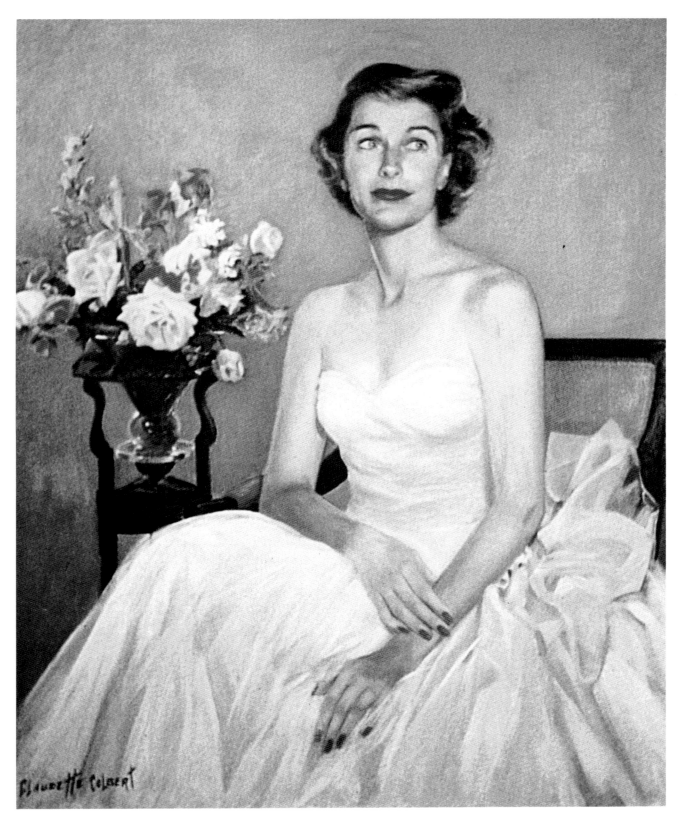

Mrs. James Stewart, 24" x 36", oil on canvas

Gary
Conway

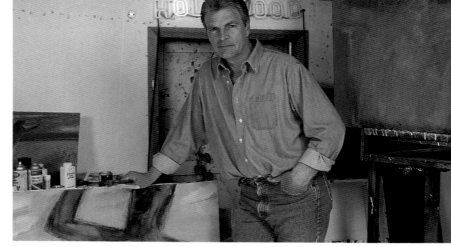

I started out as a painter. I was very serious about art at a young age. I was drawing and painting portraits on commission by the time I was eleven years old. I began to study drawing and painting at local art schools.

I was the youngest person ever given a full scholarship at Otis Art Institute, which was the leading art school in Los Angeles at that time.

I enrolled at UCLA rather than continue at Otis, or for that matter any other art school. I was soon considered too cocky for the UCLA art department. They thought I had the attitude of someone already able to draw and paint better than the teachers. Whatever the real attitude, I felt isolated and uninspired. I was committed to a university education so I switched to art history rather than involve myself any further with drawing and painting courses.

I realized that as an artist it would be difficult for me to play the games required in the art scene. I also had a reticence about having to sell my paintings for something as ordinary as making a living.

The human form was always an anchor in my explorations in painting. Abstraction began to interest me. As soon as I had mastered the human form I wanted to break out in every which way.

I identified early with figurative expressionism. To this day, my vision in art is still focused through the lens of expressionism. But often I strike out in any direction that might catch my fancy. For this book, I have included a self-portrait of a character that I played in the film The Farmer. *It demonstrates how realism remained an issue for reexamination.*

In my more recent works, it is still the human form that is central. More often than not, there are departures into a kind of kinetic primitivism. I am addicted to outrageous, if not violent, color. I will paint the same form and composition repeatedly, always with a wanderlust into the universe of color.

Gary Conway has appeared in over two-hundred television shows. He starred in two television series for ABC: "Burke's Law" and "Land of the Giants."

His feature films have ranged from the starring role in the cult classic *I Was a Teenage Frankenstein* to *Once Is Not Enough.* His own feature, *The Farmer,* began his sojourn into independent film making.

As a screenwriter, Mr. Conway wrote *Over the Top,* which starred Sylvester Stallone, and *The Smuggler,* a film planned for Eddie Murphy.

Mr. Conway has also expanded his artistic interests into architecture. He has designed and constructed many homes in Southern California as well as a *Design West-*featured condominium complex in Universal City.

Conway's first art exhibit was at the age of fourteen. Since then, he has had several one-man shows and his work is represented in several collections.

Gary lives in Los Angeles with his wife, Marian.

The Farmer, 30" x 40", oil

I started my career in art as a painter and began sculpting at the suggestion of Richard Basehart's wife, Diane, who was a sculptress. After looking at my paintings, she felt that I'd be good at sculpting and proceeded to put a file in one hand and a piece of alabaster in the other. That was it. She taught me all the basics and the techniques.

I went to Italy and worked on my own in the stone carving studios. I've been going every year for the past ten years. I go to the studio of Paoli Silverio in Pietra Santa and stay for a few months. I go into the quarry, choose my stone, and carve it in his studio. I did six pieces last year.

Hazel Court

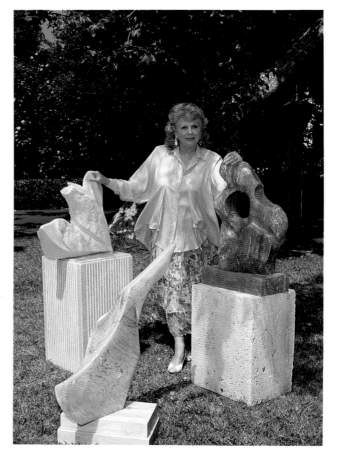

I feel that my sculpture is an extension of acting. Being involved in the arts for me is a whole new career. I started in my late fifties and it has been wonderful for me. I like it as much as acting. I like the hard work and the physicality.

I think that we all have a talent in us that sometimes only comes out in our old age. I'm so lucky because I love to sculpt nature and her shapes. I know that I will run out of time, but nature never does.

The stone always tells me what's in it. Some people don't work that way. They have something in mind and they make the stone fit what's in their mind. I don't work that way. I look in the stone and the stone fits me. Sometimes when I'm carving, I hear a little voice in there telling me which way to go.

I once had a black stone in Italy and it was a bad stone—a bad black stone. I said, "You're not going to beat me." Well, it did beat me and I got angry with it. I ended up throwing it against the wall. Something was trapped in there millions of years ago.

The actor's imagination is tremendous. I think that's why so many of us paint and sculpt. It's the natural extension for a creative person.

For me, sculpting is such wonderful therapy. When I'm carving in Italy, I'm euphoric. I sometimes think, "Where I'm carving now, Michelangelo once carved, right here in Pietra Santa." The place is charged. The spirits are there.

I've noticed that dedicated artists like Picasso, Leonardo, and Michelangelo often live to ripe old ages. I think it's because the juices are always flowing. It produces longevity—the creativity, the passion, the stirring of the juices.

Hazel Court has starred on stage, in films, and on television both in the United States and in her native England. She first crossed the Atlantic to appear in the TV show "Alfred Hitchcock Presents." Many films followed, a number of which she co-starred in with her friend and mentor, Vincent Price.

In the 1960s she moved to California and married actor/director Don Taylor. With the birth of her son in 1967, her acting career came to a halt and her energies focused on painting. In a short time, a major exhibition of her oils was held at the Kay Oberfeld Gallery in Palm Springs.

At this time another good friend, the well-known sculptor Diana Basehart, introduced Ms. Court to the artistry of carving stone. She worked with Ms. Basehart for the next four years. Another ten years was spent sculpting in Pietra Santa, Italy. In that small, thousand-year old village, the home and creative springboard of such artists as Isamu Noguchi, Harry Jackson, and Henry Moore, she worked on some of the most exquisite stone in the world.

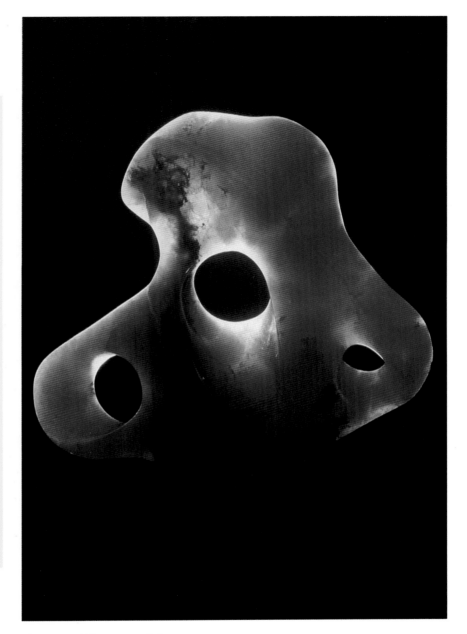

Flamenco, 18", orange alabaster

Phyllis Diller

I have had no formal training in art. I have been "drawing pictures" all my life.

As a child I was able to sketch likenesses of people.

When I run out of things to read on an airplane, I sketch.

To me art is therapy. It soothes the nerves and knits up the raveled sleeve of care.

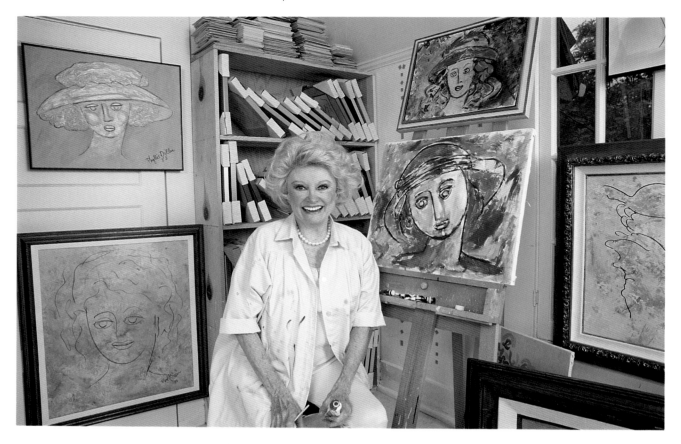

A late bloomer, Phyllis Diller started her career in show business at the age of 37. Urged on by her husband, she prepared an act and was booked at San Francisco's Purple Onion. Following her debut, she polished her act, played other night clubs, and appeared on "The Jack Paar Show."

Ms. Diller has starred in three TV series and countless specials. Her movie career began with a brief role in *Splendor in the Grass*. Since then she has been in many other movies, including a dramatic role in *The Adding Machine*. She has appeared in countless supper clubs, concert halls, and hotels and has recorded several comedy albums.

The highlight of her stage career was her portrayal of Dolly Gallagher Levi on Broadway in *Hello, Dolly!*

Ms. Diller lives in Brentwood Park, California. For her seventieth birthday, she gave herself an artist's studio where she paints in acrylics and watercolors.

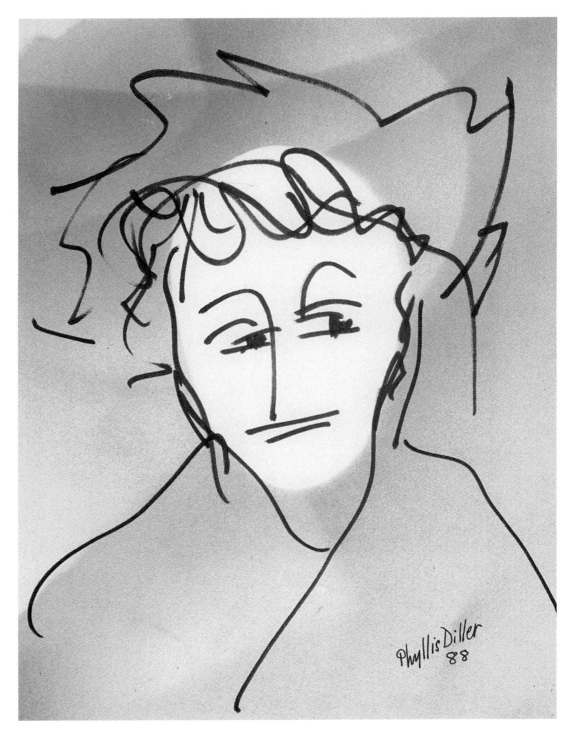

Aunt Hat, 8" x 12", ink & wash

Dennis Dugan

I never had any formal training as an artist. I gave up art in grade school because I couldn't draw a tree that looked like a tree. The real artists could draw what they saw. Now, years later, my artwork and, more recently, my film directing are perfectly logical extensions of my acting work. All three disciplines, distinctly different, seem to me to be the same. I now have the capability to express what I see.

Any character I create is a bizarre patchwork of past experiences, observations, people I know, and pure imagination. The ingredients are endless. Just as a good character grows or changes in a story, all of my artwork experiences some change, which is why I work in multiples. I try to make the images change the way they do in my mind.

You spend all day, every day, looking at stuff—the cat, the freeway, bills, stores, TV, the clock, food, people. Then some artist paints one of these things, or he sculpts it, and suddenly, magically, you see it as if it were for the first time. My work is all about that joy— the repetition and alteration of something that results in a change of perception of it.

Next week, my views on calf roping, strip-mining, and a day in the life of the mudmen of New Guinea.

Dennis Dugan is an actor whose twenty-year career includes the portrayals of such characters as Richie Brockelman in the series of the same name, Captain Freedom on "Hill Street Blues," and Maddie's husband, Walter Bishop, on "Moonlighting." He has appeared in numerous television series episodes, TV movies, and over twenty motion pictures including *The Howling, Norman, Is That You?, Can't Buy Me Love, Day of the Locusts, Smile,* and *She's Having a Baby.* He has also directed many TV shows including "Hunter," "Wiseguy," and "Moonlighting."

In 1989, he made his feature film directing debut with *Problem Child.* He recently directed a comedy for the Zucker brothers.

Proof Through the Nightmare, 20" x 40", mixed media

John Ericson

I had no formal training. I got straight A's in art when I was a kid but that was about it.

I got back into it through a friend of mine, Dick McKenzie, an artist. He had dinner at my home one night and expressed some enthusiasm for my paintings.

My dad painted like Grandma Moses. When I was a kid we used to go out to Redrock Farm and watch him paint. He said, "Why don't you do some of this?" So I did.

At the beginning I did more charcoal and pencil. Later on I got into the use of oils.

I work from photographs. I usually can't stay around long enough to work live. Sometimes I take a piece of one picture and combine it with a piece of another.

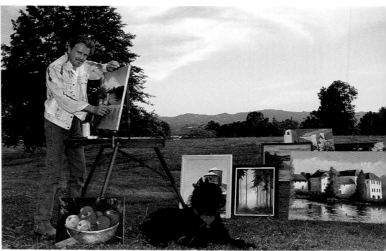

I painted a windmill once. There were vanes on it but I removed them for the purposes of the painting. It looked too cluttered. I liked the stark simplicity of the composition without them.

I never use brushes. I use a palette knife. A neighbor of mine reprimanded me for using brushes all the time and talked me into using palette knives. That's how I've worked ever since. I like the suggestion that knives lend. I have a tendency to get hung up on detail. The knife frees me from that.

Actors have to wait for parts but with painting you can get into a direct expression of your art. It's very fulfilling.

Soon after being graduated from the American Academy of Dramatic Arts in New York, John Ericson was chosen to star with Pier Angeli in the Fred Zinnemann film *Teresa*. Within a week of the film's opening, José Ferrer asked him to star on Broadway in *Stalag 17*. He later toured in the show.

His Hollywood career restarted when MGM signed him to star with Elizabeth Taylor in *Rhapsody* and Grace Kelly in *Green Fire*.

On television, he starred in the series *Honey West* and on stage he has starred in plays and musicals such as *A Streetcar Named Desire* and *Funny Girl*. His favorite role is King Arthur in *Camelot*.

Mr. Ericson's first one-man art show was held at McKenzie Gallery on La Cienega, where he sold twenty-two of his thirty-one paintings.

He is married to actress/writer Karen Ericson.

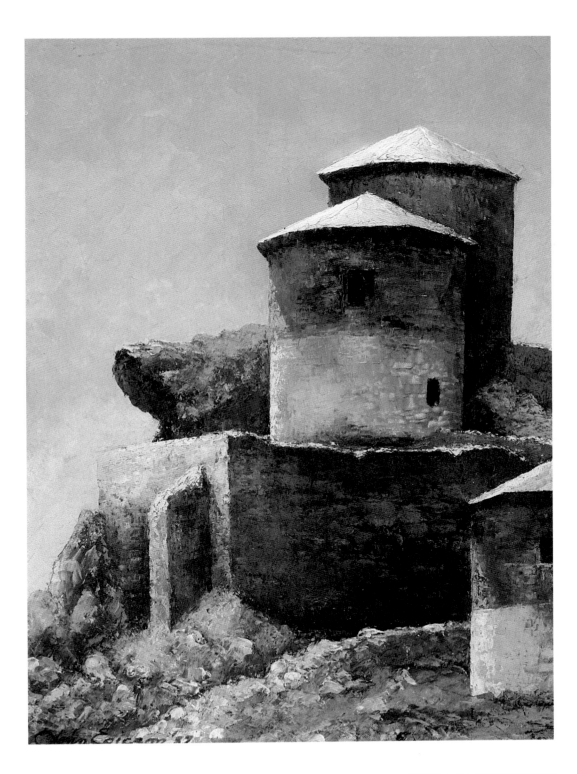

Peter Falk

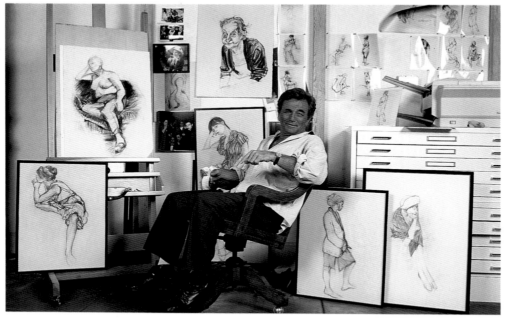

My idea of heaven is to get up in the morning and be able to draw all day long. It's satisfying to be totally involved. That reminds me of the story of the artist who was in his studio drawing a nude. It wasn't going well so he told his model to put on her robe. As they were sitting having a cup of coffee, he heard his wife's car approaching and said to the model, "You better get your robe off or my wife will think there's something going on."

People ask me why I don't work in oils. I say that I didn't start acting until I was twenty eight and I didn't get married until I was thirty one. I move very slowly. I don't jump in. I've been drawing in black and white for ten years now and I figure that in another ten years I'll be ready to go to color. I'm not a daredevil. Working in color could give you a heart attack. I've always felt weak in color. Women are great at colors. My wife instinctively knows color. Once she wanted a certain color for a room and described it as the color of the inside of a banana. Another time she wanted her car painted and came up with the color eggplant. Everything in its own time.

I just want to learn to draw. I like what Michelangelo said to the Pope when he admired his work in the Sistine Chapel: "It's all in the drawing. The rest I can get by pissing on it." Degas requested that they put on his tombstone, "Here lies the fellow who liked to draw." I love to look at Degas's drawings. I'm amazed at what he could do with a pencil and a piece of charcoal.

Oh, if there were no golf! It's the only thing that competes with my drawing.

When I was a kid there were only two kids in my class who could draw: Danny Goltier and me. I always thought that Danny was the real thing and I was a fake. Why did I decide that? Because when Danny drew, he didn't have to look. He would draw animals and other things with just his imagination. I couldn't draw unless I looked. I thought that if you looked, that was cheating. I believed that until I was in my mid-forties. It was

1964 and I was shooting a film called Castle Keep. I used to play poker with Tony Bill, Patrick O'Neil, Michael Conrad, Scott Wilson, and Bruce Dern. When I got bored playing, I used to do drawings of this old Italian leather valise I found in my room. We were staying in a castle and there was a very good sculptor who worked in the basement. One day he came into my room and admired the drawings of the valise and told me that I had talent. I said, "Well, I have the valise right here. I'm looking right at it." He told me that's what you're supposed to do. He said, "A lot of guys do that. If you go to art school, they'll let you look. It's OK." Well, what do you know about that! A light went on! I know it sounds dumb but it's true. That's when I started going to museums, reading books, studying, and drawing seriously.

In 1971 I did Prisoner of Second Avenue in New York. I was doing the play at night and had my days free so I started going to the Art Students League. It became like golf or dope. I couldn't do anything else. I was addicted. It took me over. I was totally involved. Whenever I had some free time I would attend drawing classes where there was a live model. When I wasn't working I would drop in and draw. There was this great old teacher who would yell every time he passed me, "big and fast!" I'd be intently concentrating on the eyeball and he'd come by and he'd say, "big and

Sketch, 20" x 26", pencil & charcoal

fast!" And finally it got through to me that in the beginning I had to loosen up, at least make a spontaneous mark, put some life into it. I remember that being very helpful.

While working as a management analyst, Peter Falk studied acting at the White Barn Theater. At the suggestion of Eva Le Gallienne, he began to act professionally and soon made his debut in an Off-Broadway production of Moliere's *Don Juan*. That was followed by an appearance in Eugene O'Neill's *The Iceman Cometh*, for which he won an Obie award.

In 1972, he received a Tony Award for his performance in Neil Simon's comedy, *The Prisoner of Second Avenue*.

He has received two Oscar nominations—one for *Murder Inc.* and the other for *A Pocketful of Miracles*. For his performance in *The Price of Tomatoes*, he received an Emmy Award.

Mr. Falk's most famous role is that of "Columbo," for which he has won three Emmy Awards. The series ran for six years and returned to TV in 1989.

Peter Falk enjoys drawing, preferring charcoal, pencil, or crayon. A series of his original, hand-drawn lithographs has been published.

Self Portrait, 18" x 24", pencil & charcoal

Sketch, 20" x 26", pencil & charcoal

Sketch, 20" x 26", pencil & charcoal

Henry Fonda

I guess I spend a good deal more time preparing a painting than I do the actual painting itself. I suppose a painting that might take me a week in the actual painting could have been three or four more weeks getting the idea, choosing the subject.

I'll drive all over looking for landscapes before I find one that excites me or makes me decide that this is what I want to paint.

If it's a still life, assembling and positioning the objects to be painted takes much longer than the actual painting.

I am what would be called precise in my painting. I think that I am probably that precise in my work as an actor because I don't want it to look like acting. I want it to be absolutely surreal. I want the audience to accept it as a person rather than as an actor performing.

I was never sure when I was going to get a chance to paint so I did nothing but still lifes. I felt too self conscious to ask somebody to pose for me because I get so involved that they'd have to hold a position for four, five, sometimes six hours. Inanimate objects will wait for you.

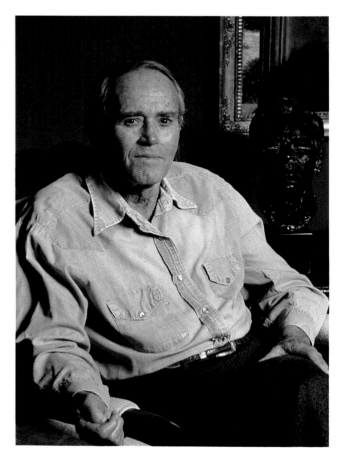

As a young man Henry Fonda moved from one job to another until, in 1925, he stumbled into Omaha's Community Playhouse, where he was talked into picking up a script by Dorothy Brando, mother of Marlon Brando. Later he joined an ambitious group at the Cape Playhouse in Dennis, Massachusetts.

Broadway was not very hospitable to Fonda at first but his luck changed when he was appearing in a stock presentation *The Swan*. His performance led to a major role in *The Farmer Takes a Wife*. He was an instant hit.

When *The Farmer* was made into a film, Fonda reenacted his stage role and became a movie star. Many pictures followed including *Jezebel, Young Mr. Lincoln, The Grapes of Wrath, The Lady Eve, My Darling Clementine, Mister Roberts,* and *On Golden Pond*, for which he won an Oscar for Best Actor.

His first love was always the stage and he appeared in many plays including *Mister Roberts, The Caine Mutiny Court Martial,* and his one-man show, *Clarence Darrow*.

Fonda has three children, two of whom, Jane and Peter, are established stars. His widow, Shirlee, lives in Beverly Hills, California.

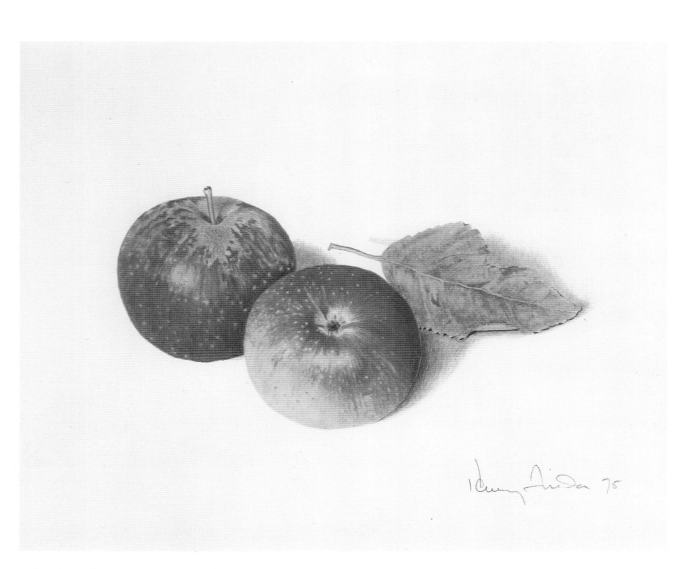

Still Life, Apples, 22" x 28", watercolor

John Forsythe

Art is an essential. It instructs, it inspires, it illuminates, and it enhances our lives.

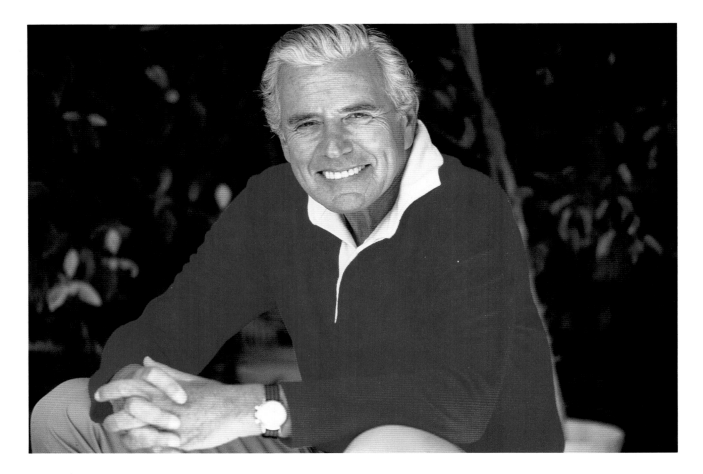

John Forsythe began his career as a sports announcer at Ebbet's Field, home of the Brooklyn Dodgers. That led to a stint as a radio actor. His first Broadway appearances in *Vickie* and *Yankee Point* led to a motion picture contract with Warner Brothers. He made his Hollywood debut in a film with Cary Grant called *Destination Tokyo*.

After serving in the Army Air Corps during World War II, Forsythe was selected for the cast of *Winged Victory*, Moss Hart's stage musical. From there he went on to such plays as *All My Sons*, *Mr. Roberts*, and *Teahouse of the August Moon*.

His early television credits include appearances on "Studio One," "Philco Playhouse," and "Robert Montgomery Presents." He was also the host/narrator of the wildlife series, "World of Survival." He has appeared in three very successful TV series: "Bachelor Father," "Charlie's Angels," and "Dynasty." His performance as Blake Carrington on "Dynasty" has earned him Emmy nominations and two Golden Globe awards.

Forsythe is an avid tennis player and owns and races a number of thoroughbred race horses. He has three adult children.

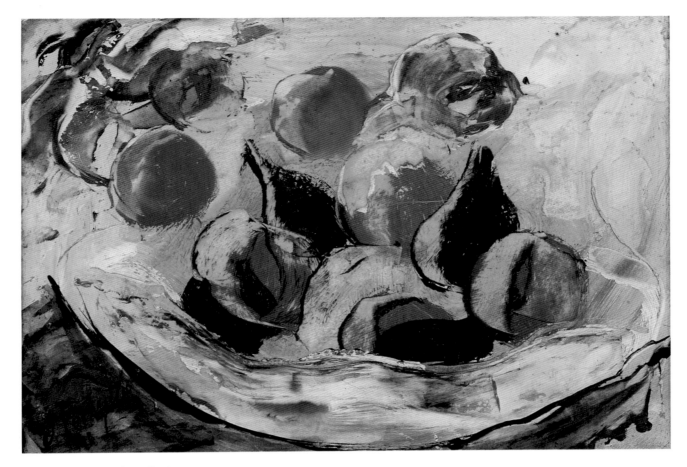

Peaches, Pears, and Stuff, oil

Dick Gautier

I'm an inveterate doodler, persistent to the point of being compulsive. Take that away from me and I'd twitch and get into all sorts of trouble.

Painting is total sanity. No one to challenge you or taunt you or oppose you. No one is right and no one is wrong. The freedom that painting or drawing (I draw well; I don't paint well) affords me is what's appealing. There are no limitations save a couple of minor things like dimension.

I try to make my work look four dimensional. There's no such thing, of course, but it's a neat little intimidating thing to say to the people who think they know about art. No one knows about art, especially me. That's why I've written four books about it.

I did a painting when I lived in New York. It pictured a huge limp watch drooping over a bridge that spanned a choppy river. In the distance was European architecture. Some of my friends hated it and called it semi-surrealistic, Daliesque garbage. Others slapped on self-important faces, nodded, grunted, and asked its title. I indicated the small brass plaque at the bottom of the frame that read Watch on the Rhine. *Cruel, but a way of separating the phonies from the "realies."*

I'd like to see more humor in art. Painters like Jack Levine and Charles Bragg are too few and far between. They are perspicacious observers of society and its foibles. The public has always been impressed by somberness. It means that this piece is to be taken "seriously." Humorous art is too often dismissed as frivolous. I think it's the exact opposite. Humor can disguise the weightiest of messages in a palatable form while the proselytizing soapbox approach tends to put people off. Humor is a crafty and powerful weapon if used correctly.

Faces reveal more than shoulders or arms so I paint faces. Body language is important but the face tells it all, if there's anything to tell. When I walk down the street, I see some faces that look like blank canvasses—no inner life, nothing going on in there. I'd like to stop them and paint faces on them, give them a point of view, a feeling, anything.

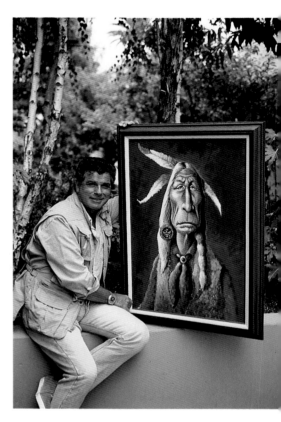

Dick Gautier was drawing cartoons for his Los Angeles high school paper when he was 16, singing with a band when he was 17, and doing standup comedy in a nightclub when he was 18. And his career has been that eclectic ever since. After school and his discharge from the Navy, he opened at San Francisco's prestigious "hungry i" where he plied his comedy wares for a year; he then traveled East to Manhattan where he played all the major supper clubs including The Blue Angel where he was spotted by Gower Champion and signed for the title role in "Bye Bye Birdie", for which he received a Tony and Most Promising Actor nomination.

After two years on Broadway he returned to Hollywood and proceeded to star in five television series including "Get Smart" where he created the unforgettable character of Hymie, the white collar robot, and for Mel Brooks in "When Things Were Rotten" he portrayed a dashing but daffy Robin Hood. Add to this list over 300 guest starring roles on TV and in motion pictures, writing and producing films, directing stage, and authoring and illustrating three books for G.P Putnam, "The Art of Caricature," "The Creative Cartoonist" and "The Career Cartoonist," and you'll get a slight idea of his range. Dick has done everything from painting portraits on commission to designing greeting cards and demonstrating pogo sticks at Macy's. All in all I guess you'll have to agree that Gautier is (as he's occasionally fond of calling himself) a renaissance dilettante.

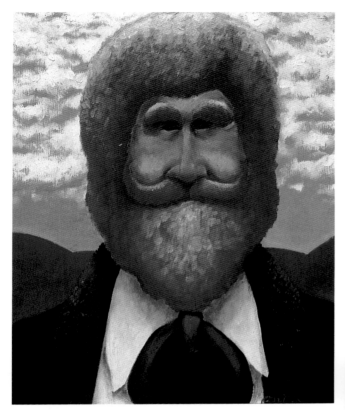

Redbeard, 24" x 30", acrylic

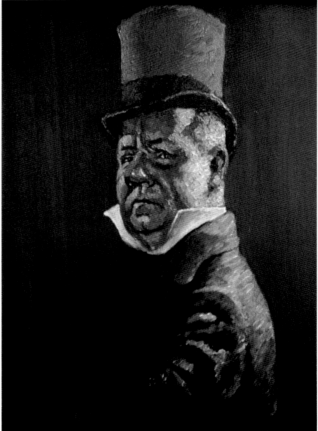

W.C. Fields as Micawber, 18" x 24", oil

Bruce Glover

Nightly, we return to the arena of our dreams. Sometimes it's a nightmare, confronting unresolved fears in grotesque monster forms. Sometimes it's a carnival, indulging in the goofy or celebrating the sensuous. Art for me is similar, an arena where anything is possible. The results are riotously disturbing, even disorienting, or joyous, or playful, or healing, but creating and having an experience that moves toward some kind of illumination. The artist is guiding the audience, making it valid by also risking the journey.

The hack uses and re-uses the tricks of easy availability, settling for cheap success. The experimental artist makes you reach a bit because he is making the same reach, often in danger, tempting failure, pushing closer to the edge.

I feel best about acting when I am as surprised by what I am doing as the rest of the audience. The same goes for painting, writing, teaching, acting, sports, and raising children. There should always be a touch of improvisation to it. Scary, but that is the fun of it.

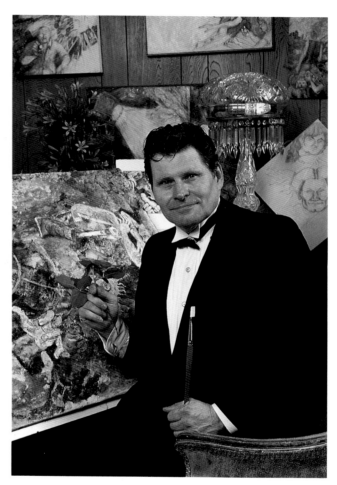

Graphics come naturally. At age three-and-a-half I drew, in an encyclopedia, a house with arms, legs, and a spraying penis—the result of a first boyish defiance of the rules. It was a somewhat guilty celebration of peeing on the side of the house. Naturally, from then on, art brought me lots of attention.

I had no formal art training. I modeled at the Art Institute in Chicago. Hearing what seemed like too many rules about art felt stifling. I hated watching a teacher make a correction on a student's canvas. I decided what would be best for me was to just look at a lot of art and do a lot of art. So I did and I still do. I have looked at and been enlightened by every artist, even the ones I hate.

Bruce Glover is an actor, acting coach, and a painter. He has appeared in 43 feature films such as *Diamonds Are Forever, Hard Times, Chinatown, Walking Tall,* and *Chain Dance.* He has starred or co-starred in more than one-hundred plays, on and off Broadway.

On TV he has appeared on over 200 shows including "Benson," "Days of Our Lives," "Facts of Life," "Hart to Hart," and "Police Story."

He lives in MarVista, California, with Betty, his wife of 32 years, who is an actor and ballet dancer, his son Crispen, a film actor, and his other son Michael Lee, a professor at Orange Coast College.

The Young Actor (Crispin) Creating Hollywood, 22" x 11", tempera on wood

It's real simple. I don't have any special philosophy about art or acting. They're both something I do because I need to. Some things I find real difficult to express in any other way than on the stage or with a pencil or brush. The best part about painting and drawing is that you're the writer, director, audience, and critic so the reviews are always good.

Cliff Gorman

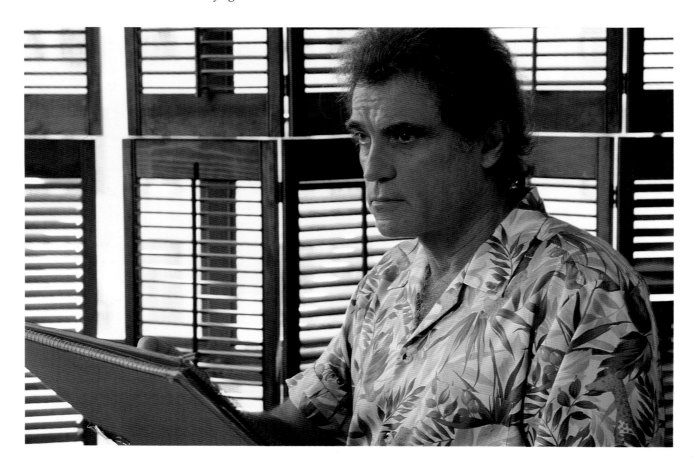

Cliff Gorman has been painting since his early teens. He attended New York's High School of Music and Art and the Art Students League. As an actor, he was an original member of Jerome Robbins's American Theater Laboratory.

His New York stage credits include *Hogan's Goat, Ergo,* and *The Boys in the Band,* which earned him an Obie Award for his portrayal of Emory. He toured opposite Maureen Stapleton in *The Rose Tattoo* and on Broadway, he starred as Lenny Bruce in *Lenny,* winning the Tony and the Drama Desk awards for Best Actor. Other Broadway credits include *Chapter Two, Doubles,* and *Social Security.*

In films he has had major roles in *The Boys in the Band, An Unmarried Woman,* and *All That Jazz.*

His TV credits include *Trial of the Chicago Seven* for the BBC, *The Howard Beach Story,* and *Murder Times Seven.* He has also guest starred on many weekly TV series including "Police Story," "Hawaii Five O," "Streets of San Francisco," and "Murder, She Wrote."

He is married to the former model, Gayle Stevens, and they reside in both New York and Los Angeles.

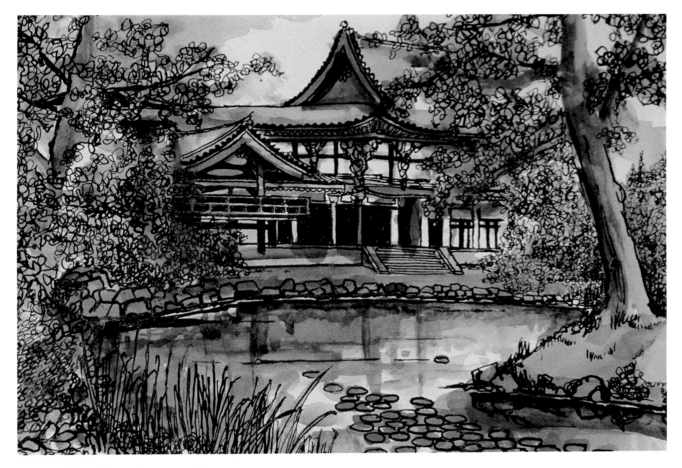

House and Pond, 6" x 8", watercolor

Coleen Gray

Art means one thing to the heart of the creator—me—and something else to the eye of the beholder. Thank goodness they don't have to be the same.

As Winston Churchill, himself a painter, said, "You either like it or you don't."

Coleen Gray has appeared in many films including *Twinkle in God's Eye*, *Apache Drums*, *Red River*, *Arrow in the Dust*, *Sabre Jet*, and *Riding High*. She has performed on over 200 television shows including "McCloud," "Ironside," "Adam 12," "Perry Mason," "Bonanza," "The Virginian," "My Three Sons," and "Days of Our Lives."

Gray has worked for many social causes including serving as president of WAIF, a unique child adoption agency. She has been painting for many years and has exhibited in various galleries. She is married to Fritz Zeisler and is the mother of two children. They live in Bel Air, California.

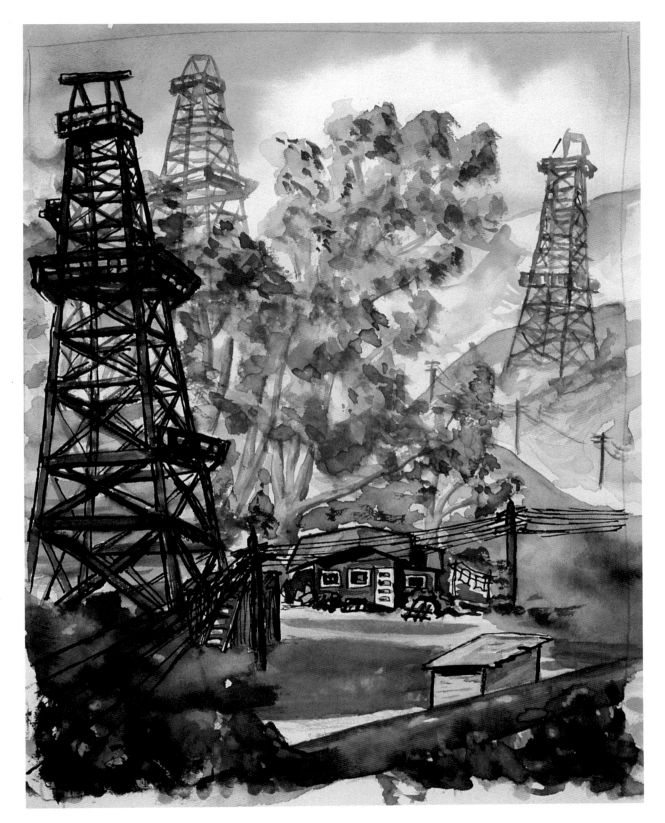

Moynier Lane, 6" x 8", watercolor

The impressive number of talented performers who also have something to put on canvas or to carve into stone should not come as a surprise. The need to express yourself without writers slipping you the lines is too strong. These are all people with something to say.

Gene Hackman

When Gene Hackman was studying at the Pasadena Playhouse, he and Dustin Hoffman were considered the two least likely to succeed. At the playhouse, he made his stage debut with ZaSu Pitts in *The Curious Miss Caraway.*

After some years in summer stock, he made it to New York, where he continued to study acting and got some small parts in TV and on the stage. He won the Clarence Derwent Award for his performance in Irwin Shaw's *Children at Their Games*, even though the play lasted one night. His first starring role on Broadway was with Sandy Dennis in the comedy hit *Any Wednesday.*

He made his screen debut in the 1964 film, *Lilith*, which also starred Warren Beatty. He worked with Beatty again in *Bonnie and Clyde* and *Reds.*

He became a major star with *The French Connection*, for which he won an Oscar. Later films include *Scarecrow, The Conversation, Young Frankenstein, Superman, Mississippi Burning,* and *Class Action.*

Mr. Hackman has three children and maintains a home in Sante Fe, New Mexico.

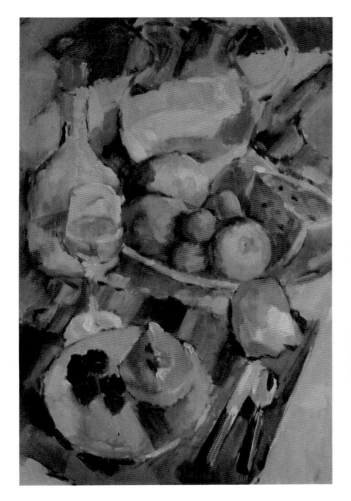

Untitled, 20" x 30", oil

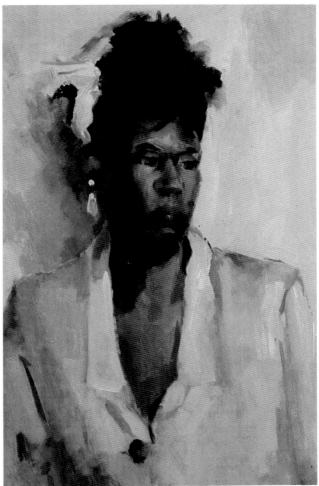

Untitled, 24" x 30", oil

I sculpt because its creative excitement is available any time I want to work. It is the perfect companion to the actor's life.

Much about three dimensional form delights me but I am especially interested in discovering ways to arrest motion so that the eye invents the whole event from that one arrested moment. Faces are particularly interesting in this context.

Jerry Hardin

I began sculpting in an effort to give full-blown form to the etchings of Jacques Callot, a fifteenth-century artist who captured the bizarre actions of the actors of the Commedia Del Arte. To lift these wild human bodies off the page and have them stand on their own two feet was a kick. I was hooked.

These first efforts were supported by people who shared my interest in the Commedia Del Arte. This encouraged me to look into other media: paper, plastics, bronze, wood, and finally, bone.

Over the years, I have remained particularly interested in the human form, faces, and an occasional digression into animal forms.

Many artists have influenced my work. I have enjoyed the creations of many sculptors but there are two or three who seem to me to have achieved a kind of perfection—Brancusi, Barlach, Lehmbruck—and their visions are often bouncing around in my head.

Bone is my medium of choice at the moment. Protected from water and direct sunlight, bone has an unlimited life, considerable strength, innate beauty, and is enhanced rather than defaced by the touch of the human hand. The boundaries of the raw material are a terrific stimulus to new solutions. There is a kind of mystic quality to the material that seems to draw the viewer to caress its form.

Sculpture is for me many things, not the least of which is a way to remain more or less sane and functional as I pursue an acting career.

Jerry Hardin studied at the Royal Academy of Dramatic Art in London. He began his professional career as an actor when he was chosen by Mary Martin as the winner of the Barter Award. The award brought with it a union membership and a year of employment.

He spent about 11 years in stock, doing one-night stands and performing in regional theaters.

Then came films. His credits include Costa Gavras's *Missing*, Paul Mazursky's *Tempest*, and Warren Beatty's *Reds*. On television, he has been featured in movies of the week, done guest appearances, and had a starring role in the comedy series, "Filthy Rich."

Sculpture has been the outlet, comfort, and haven for Jerry during those times when he wasn't performing. He has no formal art training but has, over the years, worked in a variety of media: paper, plastic, clay, wood, bronze, and bone. Bone is the material of choice at the moment and his studio resembles the catacombs, with bones stacked everywhere.

Mr. Hardin is married and has two adult children, Shawn and Melora. His wife, Diane, is an acting teacher and has her own studio.

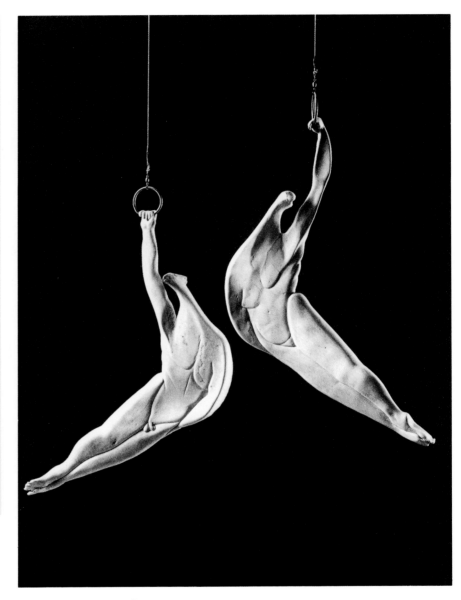

Acrobats, 10" x 18", bone

Katharine Hepburn

My escape.

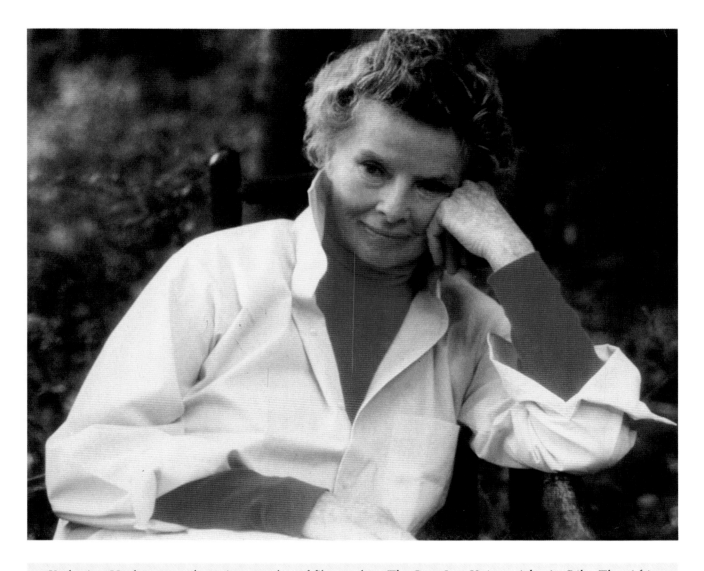

Katharine Hepburn was born in Hartford, Connecticut, on November 9, 1909. She attended Bryn Mawr College.

Ms. Hepburn began her career on stage and has appeared in many plays. Among them are *Jane Eyre*, *The Philadelphia Story*, *Without Love*, *Antony and Cleopatra*, *Coco*, and *The West Side Waltz*.

On television she has appeared in a number of films such as *The Corn Is Green* and *Love Among the Ruins*, for which she won an Emmy award.

Her greatest impact has been made in films. She has been a major motion picture star for over fifty years. Her many films include *A Bill of Divorcement*, *Little Women*, *Mary of Scotland*, *Stage Door*, *Bringing Up Baby*, *Holiday*, *The Philadelphia Story*, *Woman of the Year*, *State of the Union*, *Adam's Rib*, *The African Queen*, *Pat and Mike*, *Summertime*, *Desk Set*, *Suddenly Last Summer*, and *Long Day's Journey Into Night*.

Katharine Hepburn has won four Academy Awards for Best Actress for her performances in *Morning Glory*, *Guess Who's Coming to Dinner*, *The Lion in Winter*, and *On Golden Pond*.

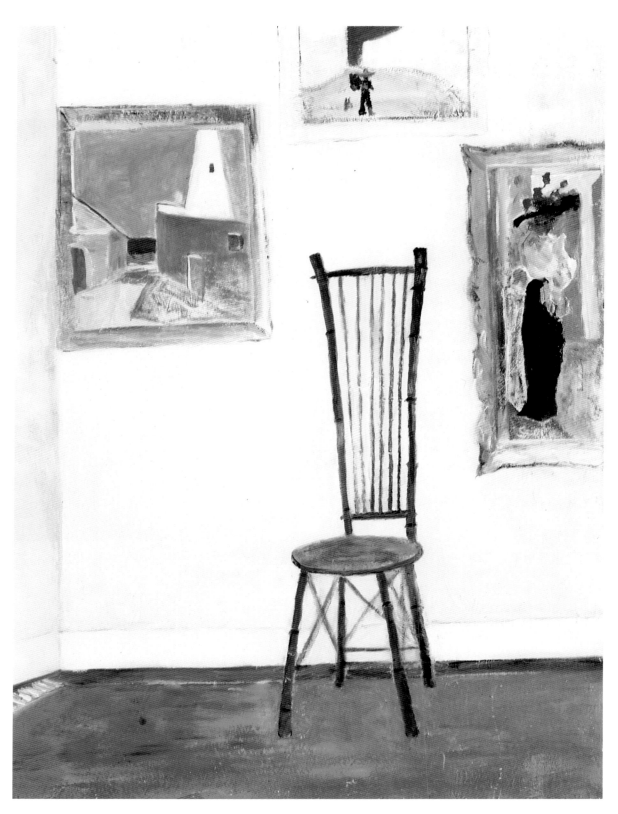

A Chair, oil

Bo Hopkins

I have had no training whatsoever. I've always enjoyed looking at art but I never took lessons, not even when I was a kid.

I mentioned to my girlfriend that I would like to try my hand at painting so she bought me a set of watercolor paints for Christmas. I didn't start using them right away. In fact they sat in the closet for a year. I think I was scared to start painting because I have no training. I felt I wouldn't be able to paint. She wrapped them up and gave them to me the following Christmas. She gave me a lot of encouragement. Eventually, I set myself to it.

I don't really have a philosophy about art. If I look at a painting and it pleases me or makes me think about the piece then I think the artist has done what he set out to accomplish—create a reaction from the viewer. For example, a painting of a man and a woman talking would make me wonder what had just happened, what they were talking about, and what relationship they were to each other. I find I can make up a whole story about one little slice of life from a painting.

I think of my acting as I do my art work—very primitive (a little joke there)! I don't know. I don't think I really relate my art work to my acting at all except that when I am playing a role on the screen I try to be as creative as I can with that character, and when I am painting I also try to be as creative as I can.

I gain satisfaction from the reaction I get when people see my work. My paintings never fail to put a smile on someone's face and that makes me feel good.

It's a pastime I never would have seen myself doing five or ten years ago. I think as life becomes more complicated one tends to search for uncomplicated things. Painting for me is a relaxation and an escape from the day's pressures.

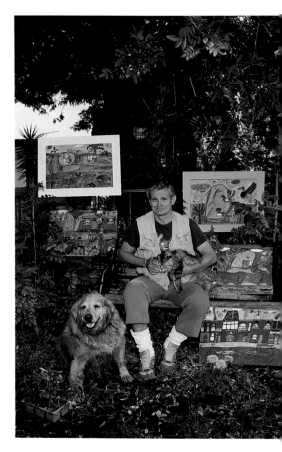

After his release from the Army, Bo Hopkins went back to his birthplace, South Carolina, where he auditioned for and won a role in a little theater production of *Teahouse of the August Moon*. His performance won him a summer stock scholarship and ultimately a trip to New York for a screen test at a major studio. Instead, he decided to go to Hollywood and won another scholarship with a school at Desilu Studios, where he appeared in a number of plays.

He soon began to get parts in television. His movie debut was in *A Thousand Plane Raid*. The producers liked his work so much that they signed him to a five-movie deal.

Some of his other films include *The Wild Bunch*, *The Man Who Loved Cat Dancing*, and *White Lightning*. On TV he has worked as a semi-regular on "Doc Elliott" and "The Rockford Files."

In addition to painting, Bo enjoys gardening and has recently written several screenplays. He has a daughter, Jane.

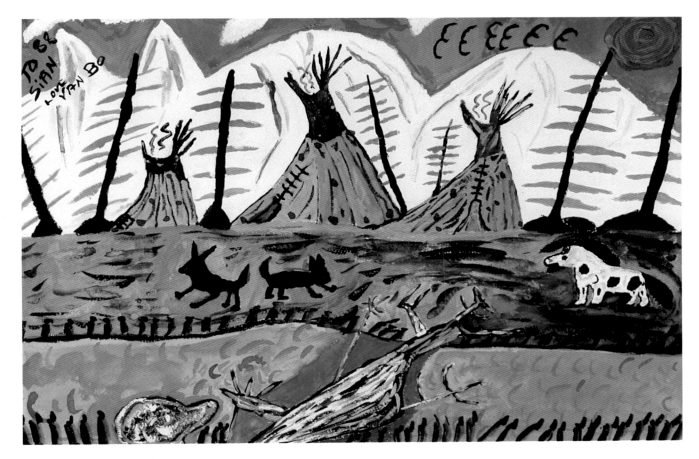

Indian Village, 22" x 14", watercolor

John Huston was very private about his art. He never cared to have people see the paintings he created and never had a public showing of them. He simply enjoyed painting and didn't care to talk about his work. Painting to him was a means of getting away from the busy world and finding peace, a way to relax and refresh himself. Some of his best work was done in Ireland in his studio above the stables at his home in Saint Clerans, Galway.

John Huston

He never considered himself a professional artist in any way; he thought of himself as an amateur. He was a collector of art and admired the work of Renoir, Juan Gris, the Italian sculptor, Manzu, the American painter, Morris Graves, and Toulouse-Lautrec, whose life he immortalized in the film, Moulin Rouge. His father, Walter Huston, introduced him to the American painter, Morgan Russell. John was very fond of Morgan's work and had several of his paintings in his Saint Clarens home.

Henry Hyde, John Huston's lawyer for 25 years, owns a sketch that John did of him: "John did the sketch one day as I was boring him to death with too many details about his tax situation."

John spent a number of years in Mexico, as a young man and at the end of his life. He fell in love with the Mexican people and with their painting, pottery, gold coins, and feathers. At one time he had a small but high-quality collection.

Born in Nevada, Missouri, John Huston was the son of character actor Walter Huston. Huston served in the Mexican cavalry at the age of 19, wrote stories for the *American Mercury* magazine, and studied painting in Europe before going to Hollywood to write for the movies.

Huston directed 32 films, many of which are considered classics. In 1948 he won an Academy Award for the script and direction of *The Treasure of the Sierra Madre* and his father won an Oscar for Best Supporting Actor in the same film.

His first film was in 1941—*The Maltese Falcon*. Other films include *Key Largo*, *Beat the Devil*, *The Red Badge of Courage*, *The African Queen*, *Moulin Rouge*, *Moby Dick*, *The Asphalt Jungle*, *The Misfits*, *Night of the Iguana*, and *The Man Who Would Be King*. He has written or co-written some of his films, including *Sergeant York*, *Jezebel*, and *High Sierra*. He and Howard Koch wrote a play called *In This Our Time*, which won the Drama Critics Circle Award as Best Play of 1941.

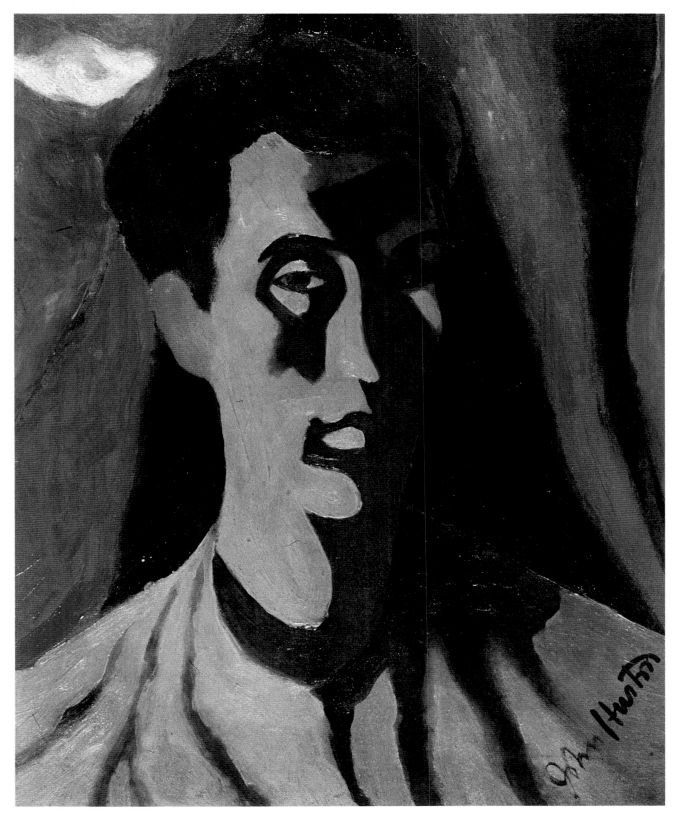

Self Portrait, 20" x 24", oil

Art is finally the language of the heart. It is a primal voice that chronically stutters when it means to speak, crawls when it aches to fly, and, at long last, as the gods take pity, soars into eloquence and resurrects itself into beauty. It is a divinely senseless beauty that will not redeem the horrors of history, will not give the human animal a purpose or a future, and is doomed to annihilation at its inception. It is a naive gesture, framed in death, that blazes momentarily in the great night so brilliantly and so tenderly that the very stars are moved to weep. And we live.

Anthony James

Anthony James was born in 1942 in Myrtle Beach, South Carolina. In 1960 he moved to Los Angeles, California, to pursue a career in film acting, all the while continuing his interest in drawing and painting, which had been a passion since childhood.

In 1967 he made his debut as the killer in the Academy Award-winning film *In The Heat of the Night*. He has since appeared in more than 25 motion pictures and over 100 television programs.

James has worked over the years to make his painting more personal and more visionary. In 1982 he entered the art market by beginning to show and sell his work throughout the United States.

He currently lives in Los Angeles.

Arcanum XXVIII, 48" x 60", acrylic on wood

I never really had any training as an artist. When I was growing up in North Carolina I thought about doing art but my sister was being groomed as "the artist." My mother was training me to be a singer: "One artist in the family is enough."

My sister, K.C. Baker, who is now a professional artist in Hollywood, had a great influence on my work. I used to watch her. All my technique comes from her. I consider her my teacher. At that time, however, I didn't dare say that I was a painter. She was the artist in the family and I was the singer.

Anne Jeffreys

Anne Jeffreys started her professional career when she was a teenager, modeling in New York while studying for an operatic career. She appeared in a musical revue, *Fun for the Money*, and that led to her winning her first movie role in *I Married an Angel*, starring her idols, Jeanette MacDonald and Nelson Eddy.

Between her many films she continued her singing career. Kurt Weill heard her sing *Tosca* and asked her to appear in his *Street Scene*. Another renowned composer, Cole Porter, offered her a major role in his musical, *Kiss Me Kate*. During the run of *Kate* she met Robert Sterling. They were married six months later. Jeffreys and Sterling created a nightclub act and eventually starred in their long-running TV comedy series, "Topper."

After two years of "Topper," she semi-retired to be a wife and mother to her three sons. She still managed, however, to appear in various musicals such as *Kismet* (with Alfred Drake), *Camelot*, and *Destry Rides Again*.

Many years later, after I'd become an actress, I was in my manager's office and noticed a wonderful painting by an artist named Foss. Something compelled me to ask if I could copy the painting. I bought paints and copied it stroke for stroke. For a long time I just copied famous artists. That's how I learned and developed my technique.

I remember taking a painting course at UCLA. I thought it was in oils but it was a watercolor class. I stuck with it and was glad I did.

When my kids were little I used to go down to the basement and turn on a single light bulb and paint into the wee hours.

I'm a complete artist. If I couldn't act, sing, paint, or perform I don't know what I'd do.

Everything I do is an experiment. I keep trying to find my own style but that is difficult because I don't paint enough. I'm influenced by the impressionists: Manet, Monet, and Renoir. I love Renoir.

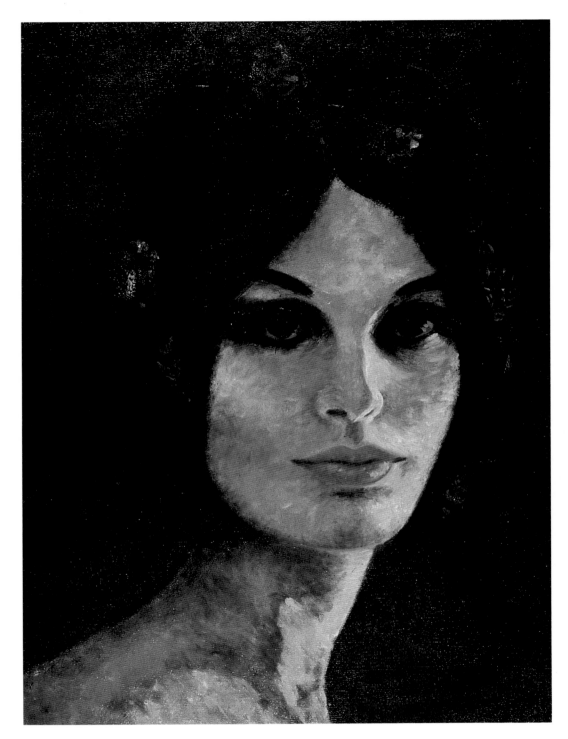

Lady, 18" x 24", oil

When I got to Hollywood and we had Saturdays and Sundays off, there were a bunch of us like Claudette Colbert, Jane Wyman, Dinah Shore, Claire Trevor, Gary Cooper, and Hank Fonda who used to get together at

Van Johnson

Gary Cooper's on Sunday nights. We all brought our oil paintings and compared and criticized. We sort of all taught each other. Claudette Colbert and Claire Trevor inspired me. Jane Wyman taught me to paint right out of the tube. That's how I work now. I use a knife. I don't have time for a brush. It was great occupational therapy.

I discovered that I saw colors in trees, people, and life that I never saw before. Then I started going on trips around the world and I'd paint out of hotel rooms. I painted in Venice, Rome, and Berlin.

I think it's very important to have many hobbies. It's great therapy for me because it keeps me out of the icebox. I keep a picture of Audrey Hepburn on my fridge because she's so bony, thin, and beautiful that I close the door and get back to the easel.

I paint every day. I get up very early and paint all day. I stop at five or six or whatever and throw everything out.

I'm self taught. I use acrylics because they dry quickly.

Acting in relationship to painting? Well, painting is colorful and creative. Acting is the biggest bore. You have to wait; you hurry up and wait. You have to get up at five in the morning and hurry up and wait. I'd rather hurry up and paint.

Van Gogh was a great influence on me because I believe in color, pure color, right out of the tube.

I paint to express my own inner happiness. Painting makes me feel young.

In the early 1940s, Van Johnson went to Hollywood where his red hair and freckle-faced grin set him apart from many other young hopefuls. Louis B. Mayer, the studio boss of MGM, signed Johnson to a long-term contract. He has starred in more than 125 films including *Thirty Seconds over Tokyo, The Last Time I Saw Paris, In the Good Old Summertime, State of the Union, Brigadoon,* and *The Caine Mutiny Court Martial.*

In 1961, Johnson left Hollywood and returned to the musical stage, where he got his start. He has appeared on stage in almost every major city in the U.S. in a variety of starring roles. He co-starred on Broadway in *La Cage aux Folles.* His television appearances include a guest spot on "Murder, She Wrote" with former MGM classmate Angela Lansbury.

Mr. Johnson had his first one-man art show in Dallas and plans more for the future.

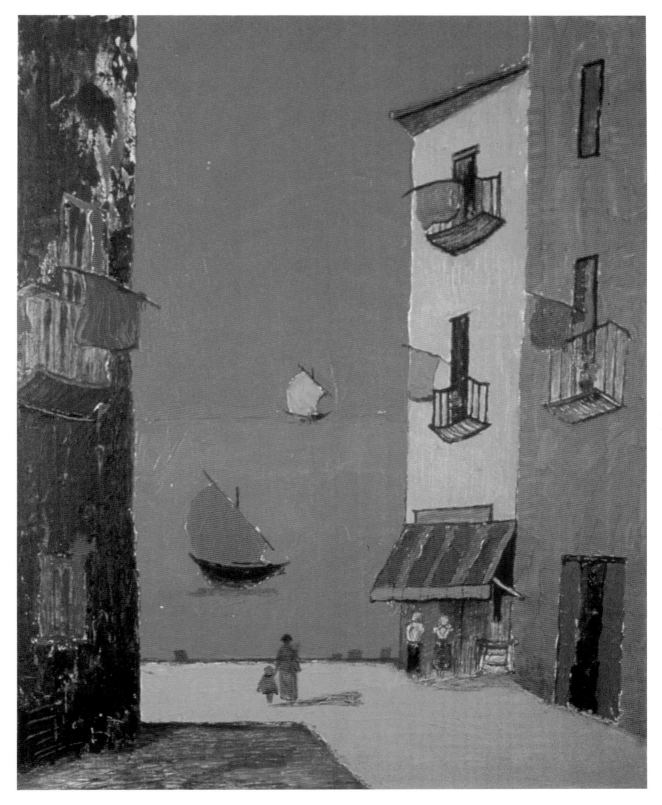

Cap d'Antibes, 36" x 48"

Steve Kanaly

After two repressive years in the Army, college seemed like heaven. I became a straight A student. My entire focus on life had changed. I became an abstract painter, leaving the confines of commercial art and challenging the unknown. No more tight, fine, and perfect. It was now bold, physical, experimental, and large. My garage studio was full of six-by-six canvasses and expressions of my struggle to define my identity.

Along the way I studied watercolors and although I still paint in acrylics and oils, it's the watercolors that make me feel the best. Art is the therapy of my film career. I wish there was more time to spend at the easel.

My subjects are usually outdoors and special in some way to me. I begin outdoors on location and usually finish at home when there is time.

Like most artists, I am very critical of my own work. I always know I could have done it better in some way. The important thing is to have tried. It's the act of painting and drawing that gives me the most enjoyment. Understanding the elements of art has enhanced my life as an actor, director, producer, and father.

After serving in the Vietnam War, Steve Kanaly worked as an instructor/manager of a skeet and trap shooting range, where he met John Milius. Milius offered him a job as a technical advisor on the film *Apocalypse Now*. The job never materialized. It did, however, pique Kanaly's interest in show business and he began to audition for parts. He soon became discouraged and decided to move to New Mexico, become a recluse, and devote himself to "emotional and gutsy" paintings.

But that plan was also not to be. John Huston, impressed with Kanaly's skills as a marksman, offered him a role, without an audition, in the Paul Newman movie *The Life and Times of Judge Roy Bean*. That led to other films such as *Dillinger, Sugarland Express, The Terminal Man*, and *Midway*.

He is a regular on television game and talk shows and played Ray Krebbs on "Dallas" for many seasons.

In addition to painting, Kanaly likes to play the piano, fish, play tennis, ski, and hunt. He is married to Brent Kanaly and they have two daughters, Quinn and Evan Elizabeth.

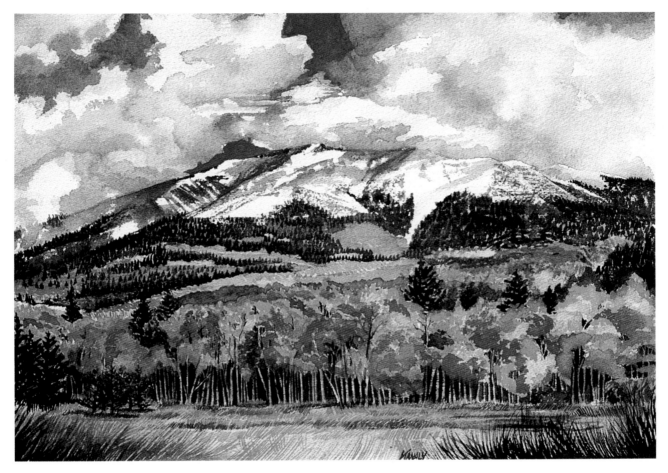

Durango, 18" x 14", watercolor

I grew up with a real sense of art around me—photography, pictures of my mother with Picasso.

It started with the Arts' Students League and then the National Academy of Design. I was very influenced by Matisse and Picasso because of the photographs around the house.

I believe in yantra. *I believe in the use of yantras, meaning that what you see affects your consciousness. So much of my painting has been sad.*

Sally Kirkland

We are light, we are sound. You look at this image and you say this is what I see. I then put it in the painting or collage or whatever I am working on.

We live in turbulent times. So what can I do as an artist? My main thrust is my transition from a life of pain to a life of joy.

In this painting I say "Listen to the Christ within." If it worked for me, maybe it'll work for them.

Sally Kirkland has worked extensively on screen, stage, and television. She has made over twenty-five films including *The Sting*, with Robert Redford, *Bite the Bullet*, with Gene Hackman, and two films with Barbra Streisand, *The Way We Were* and *A Star Is Born*. She won a Golden Globe award and an Oscar nomination for her performance as an aging Czech actress who descends into madness in *Anna*.

Off-Broadway audiences have seen her in over forty productions including Terence McNally's *Sweet Eros*. Early in her theatrical career she worked with Andy Warhol and became a leading actress for Tom O'Horgan's New York City La Mama troupe. Among the plays she has appeared in are *Tom Paine*, *Where Has Tommy Flowers Gone?*, and *One Night Stand of a Noisy Passenger*, the latter opposite Robert DeNiro. She was the recipient of the Los Angeles Dramalogue Best Actress award for her performance in *In the Boom Boom Room*.

A lifetime member of the Actor's Studio, Kirkland created the Sally Kirkland workshops, which are now operating in fifteen U.S. cities and in Australia and France.

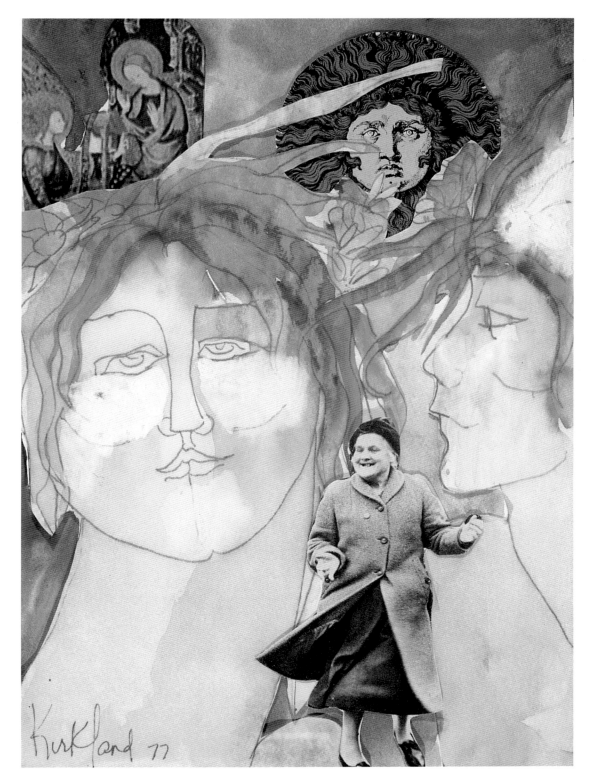

Untitled, mixed media

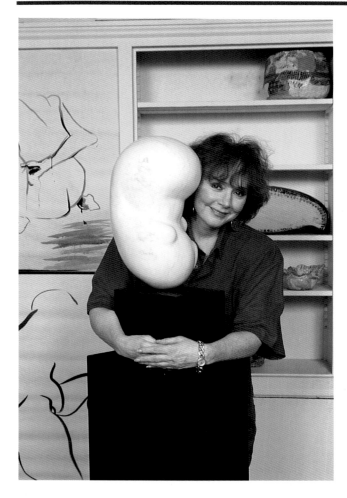

The music was the sound of the tools hitting the stone. The teacher was José de Creft, a contemporary Picasso, and he was critiquing the work. He turned to me and said, "What's your name?" and I said Rosetta Morgangetter, which was my married name. He said "Where's your work?" and I said that I hadn't begun yet. He said, "When you begin, get the biggest piece of stone that you can carry. Don't work like these people here with cookies."

The first piece I ever worked on was Vermont marble and it almost broke down the rear of our car.

I work only by hand. I don't use power tools, which I guess is unusual.

When you're working with marble it's not like going into a room and picking up a paint brush. You have to have a special place, an isolated place, because marble gets into everything. You have to dress for it. And you can't do it for an hour. It has to be for a half a day at least.

I learned that if you make a mistake in a piece of stone, it can be very serious. It will mean that your original idea is destroyed. But you can turn the piece upside down, do something else, and it's just as valid. Sometimes something better comes out of it.

When I did my first piece, I loved the material as it was. I didn't want to break into it. It took me days to risk doing that. I really couldn't decide what I wanted to do. Finally someone said, "Just chop into it; just make the first blow." That's what I did and instantly, I saw something in the stone. I went on.

I was very influenced, although it doesn't always show in my work, by Rembrandt. And I love Brancuzzi.

I guess the parallels between acting and sculpture are risk-taking. It's turning the piece upside down. It's another way of saying, "What if?"

Piper Laurie

Untitled, 18", Tennessee pink marble

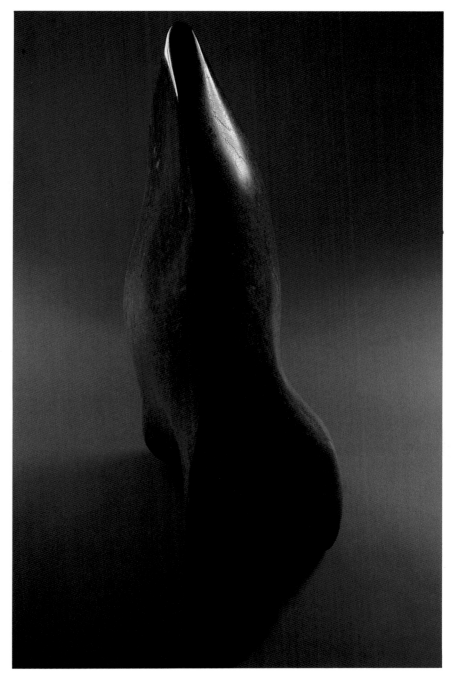

Piper Laurie began her career at Universal Studios, where she starred in over twenty movies, including *Louisa* and *The Prince Who Was a Thief*.

After struggling to find more challenging material, she went to New York to seek serious roles in live television. She won Emmy nominations for the original "Playhouse 90" production of *Days of Wine and Roses* and the "Studio One" productions of *The Deaf Heart* and *The Road That Led Afar*. During that time she also appeared in the twentieth-anniversary production of Tennessee Williams's *The Glass Menagerie*.

She returned to films in *The Hustler*. Her performance won her an Academy Award nomination for Best Actress. After making *The Hustler*, Ms. Laurie retired from acting for a number of years, moved to Woodstock, New York, and raised a daughter, Annie.

In 1976, she returned to films in *Carrie* and *Children of a Lesser God*, which both won her Academy Award nominations.

On television she won Emmy nominations for her work in *The Thorn Birds*, "St. Elsewhere," and *The Bunker*. She won an Emmy for her performance in *The Promise*.

She has exhibited her sculpture in a gallery in Woodstock, New York.

You would like me to make a comment about art? It's difficult. It's like introducing your new wife to your friends. You say, "Here she is, take it or leave it."

About my art—it's visual. Art is a visual medium. You look at it. You don't talk about it.

George Maharis

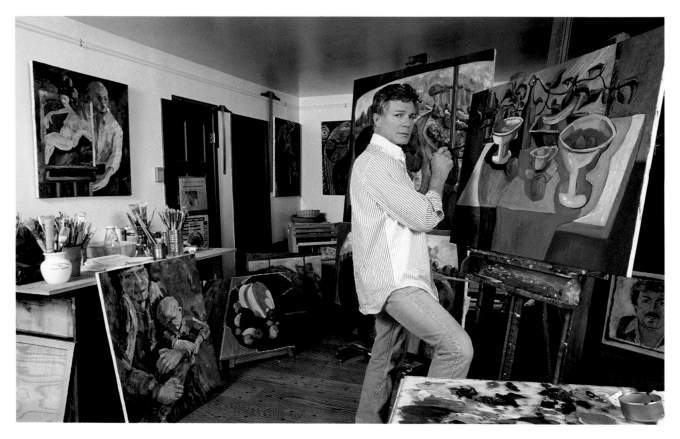

George Maharis learned how to cope with life early through the rigors of a youth in the Hell's Kitchen area of New York City. After three years in the Marines, he began a series of various jobs until he finally decided to become a singer. An audition in New York won him spots in the choruses of *Geisha Girl* and *Rose Marie*.

His big break came when he appeared in Edward Albee's *Zoo Story*, for which he won the Theater World Award as Best Actor of the Year. His first break in television was in the popular comedy series *Mr. Peepers*, starring Wally Cox.

A guest appearance on TV's "Naked City" led to the part for which he is most famous, the co-star of "Route 66." The show ran for several seasons and won Maharis an Emmy nomination and stardom.

Early in his career, Maharis took a job as an assistant to artist Edward Melcarth. Melcarth engaged him to help paint the eighty-by-one-hundred foot ceiling murals for New York's Lunt Fontanne theatre.

Today, Maharis spends much of his time in the studio atop his Beverly Hills home. He has had exhibits in New York, Chicago, and Los Angeles, and is represented in many private collections throughout the country.

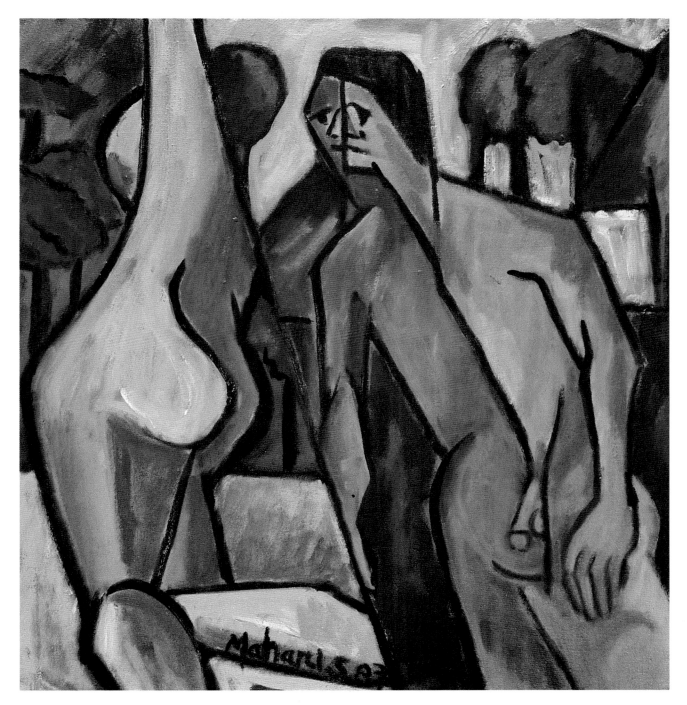

Split Decision, 24" x 30", oil

In my art work I have made no compromises. I can pour my creative self completely into a dialog with the piece I am working on. From beginning to end it is my responsibility, my imagination, my love affair with art. Acting is a road where compromise must be learned. There is no way to control the decisions of others as to who gets what role or how it will come together as a finished product. This is not necessarily a negative but it doesn't allow for the same intense immediacy of working individually.

Art is my mentor. As I evolve and grow my art responds accordingly. It beckons me onward into deeper and deeper recesses of my own heart and mind. I sense the infinite when I work as an artist. I feel connected with the rootedness of my consciousness, which is somehow within and outside the wheels of time.

I do not believe in trying to paint a philosophy of art. Art transcends philosophy. If it doesn't, it becomes merely political or ideological. A picture should be worth a thousand words. It should not take a thousand words to indicate the ideas of the artist. A picture should be an environment that exists with or without the handbook of explanations.

Each artist follows his or her own particular muse (oftentimes more demon than angel) expressing his or her inner life along the natural contours of a particular creative bent. I feel a kindred spirit with artists such as William Blake, Odilon Redon, Magritte, and Edvard Munch—the artists of the imagination, where the worlds within must find voice in the world without.

Leigh McCloskey

Leigh McCloskey is a native of California and a second-generation artist. His father, Joseph McCloskey, was one of the founders of the Malibu Art Association and is a nationally exhibited painter and watercolorist.

Leigh grew up in Malibu, attended California State University at Northridge, and later moved to New York to study acting at the Juilliard School in Lincoln Center. He has been acting professionally since 1975 performing in television, films, and theater. He was a regular on three series, the best known being "Dallas." Among his television films are *Alexander: The Other Side of Dawn*. His feature films include *Just One of the Guys* and *Cameron's Closet*.

On daytime television he has appeared in "Santa Barbara." He has guest-starred on many series including "Murder, She Wrote," "Jake and the Fatman," and "Paper Chase."

McCloskey's wife, Carla, is an assistant director and recently completed work on Steven Spielberg's *Hook*. They have two daughters, Caytlyn and Brighton, and live in Malibu.

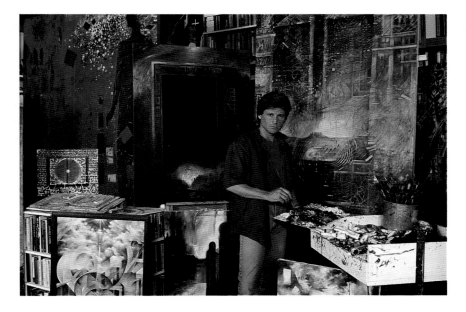

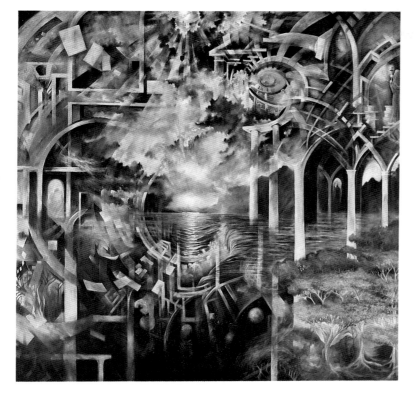

Ancient Future—Distant Past, 48" x 48", oil

Ascension, 36" x 48", oil

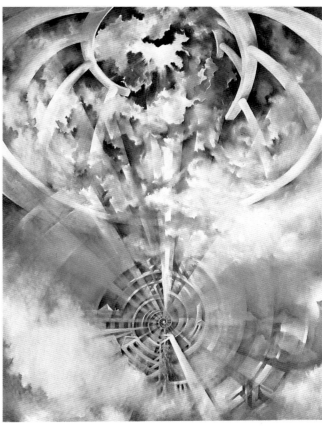

Doug McClure

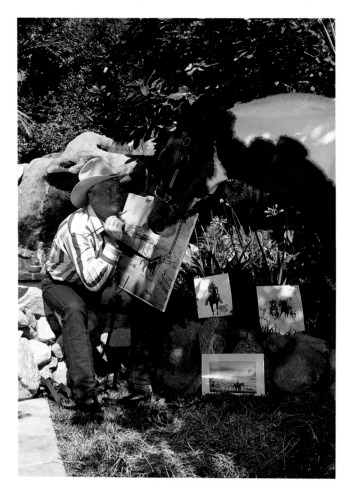

In grammar school my art teacher encouraged me. I guess she saw something there. If, at an early age, someone would have told me that I couldn't draw or I couldn't sing, it would have affected me in a negative way. So I look at my work now and I'm not too sure that the teacher shouldn't have said, "You really can't paint." Oh, I'm OK. I have fun with it and I'll always paint but its not my life. I never studied art. I just picked it up.

I paint cowboys because I understand that life. I am one. I "buckarooed" in Nevada when I was a kid. I was in rodeos and I still team-rope in competition. And then there were the years on "The Virginian"— cowboys everywhere.

Art brings out the kid in me. My paintings are whimsical, loose, and free. I often thought that I should be more mature about my art but that wasn't me. Basically, I'm a kid at heart and that's what comes out on the canvas. It makes me laugh. People seem to like my stuff.

Once when I was going through a hard time financially, Wilford Brimley paid me to do a painting of him—my first commission. I "stiffed" Wilford on that. He's a good friend, but he paid too much. One day I'll offer to give him the money back, but he won't take it.

Born in Glendale, California, Doug McClure studied drama at Santa Monica City College and briefly at UCLA. His first movie role was in *The Enemy Below*, with Robert Mitchum. The turning point in his career came with *The Unforgiven*, starring Burt Lancaster.

McClure has starred in six television series:"Overland Trail," "Checkmate," "The Virginian," later revised as "The Men From Shiloh," "Search," and "The Barbary Coast."

Among his feature films are *Gidget, Shenandoah, Beau Geste, The Land That Time Forgot*, and *Cannonball II*. He has also starred in a number of movies made for television including *Terror in the Sky, Death Race*, and *Roots*.

His Broadway debut came in *The Roast*. For his performance he was nominated for a Drama Desk award for Outstanding Featured Actor in a Broadway Play.

In recent years Mr. McClure has been a guest star on a number of television shows. He still manages to find time to pursue his favorite pastime, the rodeo circuit. In 1986 he won the Ben Johnson Pro Celebrity Team Roping Competition in Oklahoma.

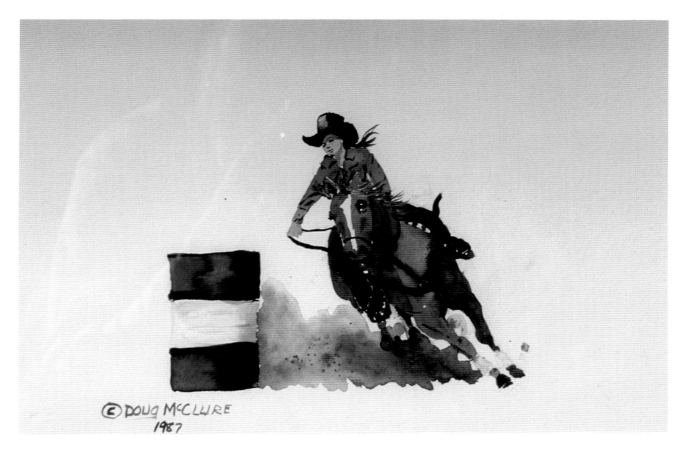

The Barrel Racer, 28" x 22", watercolor

As far back as I can remember, I thought of myself as a creator; as a kid I had this passion to make things. I always felt that I just reflected the ideas from "the source." We just pick up on them and call them our own but they're really part of the universal mind.

My parents were very supportive of my creative urges and always supplied me with materials and books.

The artist whose work has influenced me most is Antonio Gaudi, the brilliant Spanish architect. The idea of living in a piece of art intrigues me. If I would have continued in architecture, I'm sure I'd be designing sculptures to live in.

Jim
McMullan

I guess I'm a Dadaist at heart. I love the whimsy, the irreverence, the idea of art being fun, an expression of the absurd. Marcel Duchamp and Man Ray's work has had a great impact on my vision. The Zen concept of the controlled accident has also influenced me.

Art is like a disease. It hangs on. It haunts you. It gets you up in the middle of the night and says, "Go make something."

The work I do grew out of my early involvement with industrial design. I'm fascinated by odd and beautiful things. A bit of rusted metal or a piece of twisted sea-washed wood turns me on. I see these objects as my palette. They talk to me. It's a symbiotic relationship, a collaboration—the "angel thoughts," the material, and me.

Art is like Zen to me. It just happens. We listen and we act. In the moment of truth where creation begins, I explore the outer limits where reality becomes illusion and the viewer and the thing viewed become one.

Jim McMullan attended New York University, the Parsons School of Design, and in 1955 he enrolled at the University of Kansas to study design and sculpture. He was graduated in 1961 with a degree in architecture and applied for the newly formed Peace Corps. While waiting for acceptance, he flew to Hollywood to visit a friend and through a chance meeting with William Inge, got a screen test for Sam Peckinpaw's *Ride the High Country*, which led to a seven-year contract with Universal Studios.

While at Universal, he acted in such shows as "The Virginian" and "Wagon Train."

He starred as James Stewart's son in the film, *Shenandoah*. He had a continuing role on the TV series "Ben Casey" and has starred in two series, "Chopper One" and "Beyond Westworld." He has appeared as a guest actor in hundreds of other TV shows such as "The Rockford Files," "McGyver," and "Doogie Howser." In 1969 he was chosen by Robert Redford to co-star with him and Gene Hackman in *Downhill Racer*. Many people remember him as Senator Dowling on "Dallas."

Jim McMullan lives in Pacific Palisades, California, with his wife Helene and their sons, Sky and Tysun.

Roadkill #1, 27" x 21", mixed media, plaster and tar

D'Light Series (#9), 36" x 36", mixed media

George Montgomery

If a guy is going to be a good tennis player he has to study tennis. The same goes for an artist. He has to study art.

My whole life has been on the edge. I never studied art or acting. I just fell into it. I never really felt proficient as an actor but after all this time, I thought I could do a good job if I had the right part. I think it's true with anything creative. You must have a foundation, a solid place to work from.

I started doing art as far back as I can remember. Acting just happened to fall into first position for many years. Eventually, architecture and furniture-making took the first position. So many times I've said to myself, "I should study someplace," but I was afraid that I'd become a clone of the teacher so I just worked it out by myself.

Born in Montana, the last of fifteen children, George Montgomery spent his early life working on the family farm. He arrived in Hollywood in 1937. His first film was *Conquest*, starring Greta Garbo and Charles Boyer. Shortly after that, he had a starring role in *The Lone Ranger*. He played opposite such Hollywood stars as Ginger Rogers, Shirley Temple, Betty Grable, Gene Tierney, and Maureen O'Hara over a period of fifty years and over eighty-seven films. He was also a producer, director, writer, architect, furniture designer, sculptor, and builder.

Mr. Montgomery has created several trophies: the Ralph Morgan award for the Screen Actors Guild, the Hollywood Westerners Hall of Fame trophy, and the Pomona Invitation Handicap trophy.

He has had one-man exhibits of his sculpture and furniture at the Palm Springs Desert Museum, the Frye Museum in Seattle, the C.M. Russell Museum in Great Falls, Montana, the Rockwell Museum in Corning, New York, and at the Gene Autry Western Heritage Museum in Los Angeles. He was also an avid art collector.

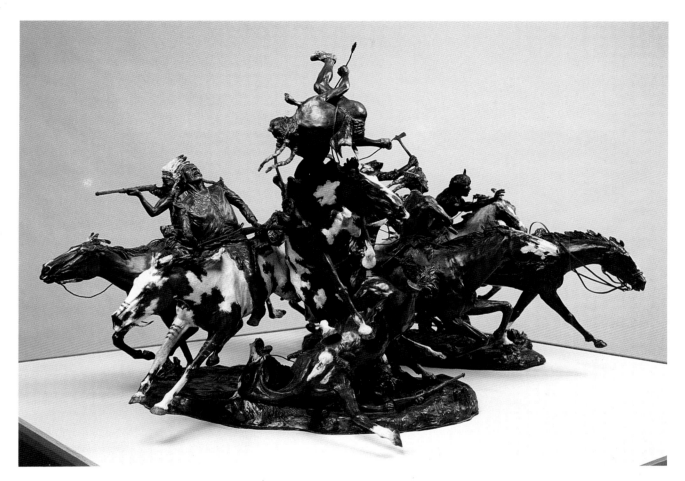

Custer's Final Moments, 56" x 27 ¹/₂" x 19 ¹/₂", bronze

Michael Moriarity

I have no formal art training but I did take some art history courses at Dartmouth College.

Art is not an avocation for me. It is more like a periodic urge to pray in a different way.

I have no philosophy about art. My pieces exist because there was no other way to reveal what was going on within me.

I don't see any profound relationship between acting and art. These pieces would have been created even if I were an insurance salesman or a doctor.

There is a good deal of self-discovery in my kind of art. No artists have influenced my work.

Michael Moriarity spent many years in regional and Off-Broadway theaters including the New York Shakespeare Festival, Boston's Charles Street Playhouse, and the Tyrone Guthrie Theater in Minneapolis.

He first came to national attention with three performances, all in one year. The first was in *Bang the Drum Slowly*. The second was as the Gentleman Caller in *The Glass Menagerie*, for which he received his first Emmy award. The third was as Julian Weston in the Broadway play *Find Your Way Home*, for which he received the Tony, Theater World, and Drama Desk awards. He won his second Emmy and a Golden Globe for his portrayal of SS Officer Dorf in the television mini-series *Holocaust*. He is currently starring in the TV series "Law and Order."

Mr. Moriarity has written three plays and all have been produced professionally. The first book of his three-book poem, *Evergrowth*, has been published in the *New York Quarterly*. He has also composed for chamber orchestra, string quartet, piano, and solo violin. He has played jazz piano in numerous clubs in the New York City area and released his first album, *Reaching Out*, in 1990.

Moriarity lives in New York City with his wife, Anne Martin, and his son, Matthew Christopher.

Prayer Two, 14" x 16 ¹/₂", mixed media

Zero Mostel

Painting was his earliest interest and his passion all his life. The story goes that he became an actor to pay for his paints and the time to use them. Among his significant gifts as an artist were an astonishingly perceptive eye and a photographic memory.

His painting technique was based on classical traditions. He believed that drawing from the live model was the basis of art and that devotion to draftsmanship was the basis of painting. It is no wonder that he was so fine a draftsman.

Springing from a study of painting in the nineteenth century, his luminous sense of color moved him to frequent use of alizarin crimson and rose madder. He loved glazes, brushes, palette knives, scumbling, scrafitto, and other antique methods. Though he tried acrylics he did not like them, the airbrush, or any of the other spurious, shortcut accoutrements used so much in contemporary painting.

He haunted Joe Torch's art store for old objects, which he liked to have around him—old bottles of sun-thickened linseed oil, old handmade papers, pencils with Siberian lead, inks, nibs, brushes, glues, dyes. He did not use all this old material, but he revelled in it and claimed that it was better made than the new stuff. If some artists are searching for the new, Zero was searching for the old; his own concepts made it new for himself.

In his search for the old, he studied the artists before him; his love of their work made him an encyclopedic scholar of art and enabled him to transmute it into his personal expression. Like Mozart he absorbed what he needed and invented his own language. Zero's paintings are all recognizably Mostels.

Upon looking at one of his paintings the son of a friend of mine said that there were "lots of places to hide." He also said that each color was saying, "Look at me." Zero's paintings are very demanding in the same way that his acting was; you have to pay attention because there is so much going on.

His self portraits are most revealing. They range from images of the painter in his studio to raging black and white beast, from Ulysses to a sad-face Tevye. Sometimes he transforms himself into a monster, a woman, an unrecognizable object. He was not afraid to portray himself as something ugly, graceless, gross. The result was always beautiful. It is a measure of his integrity as an artist that he kept some of the more horrific transfigurations.

—Tobias Mostel

Born in Brooklyn, Zero Mostel worked as a laborer during the Depression, lectured on art (his first love), and painted for a living. Soon after that, he began working in nightclubs, was heard on radio, and appeared in vaudeville. His first film was *Dubarry Was a Lady*, in which he portrayed two characters.

After his discharge from the service in World War II, he returned to Hollywood where he played a series of villains and sniveling character roles in movies such as *The Enforcer* and *Panic in the Streets*. During this time Mostel was brought before the House Un-American Activities Committee and testified that he was not a Communist. Nevertheless, he found himself blacklisted and struggled during the next few years, trying to make a living as a painter.

In the early 1960s, his career was revived not in films but on Broadway, first in Ionesco's *Rhinoceros* (his performance won him a Tony Award) and then in the Stephen Sondheim musical comedy *A Funny Thing Happened on the Way to the Forum*. Next came the role for which he will always be remembered, Tevye, in the highly acclaimed musical, *Fiddler on the Roof*. Mostel returned to the screen after a fifteen year absence to recreate his role in *Forum*. He then went on to star in Mel Brooks's *The Producers* and other films such as *The Great Bank Robbery*, *The Hot Rock*, and *Journey into Fear*. His last film before his death in 1977 was Woody Allen's *The Front*, in which, ironically, he was cast as an actor who was a victim of the blacklist.

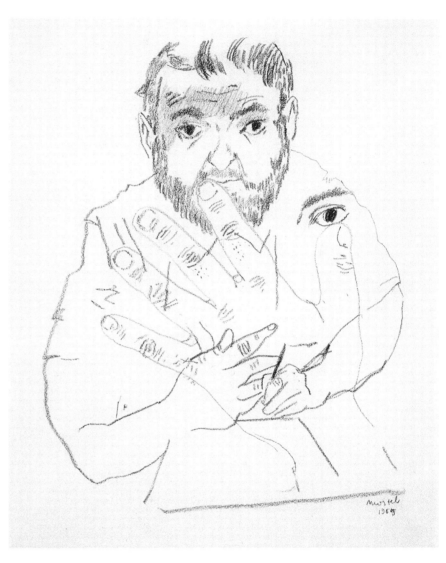

Self Portrait, 5" x 7", ink

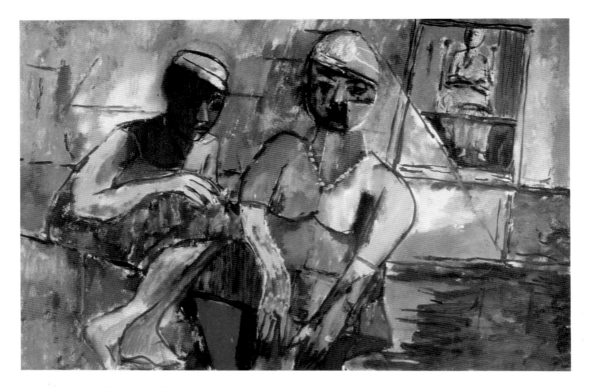

Studio Scene, 36" x 24", oil

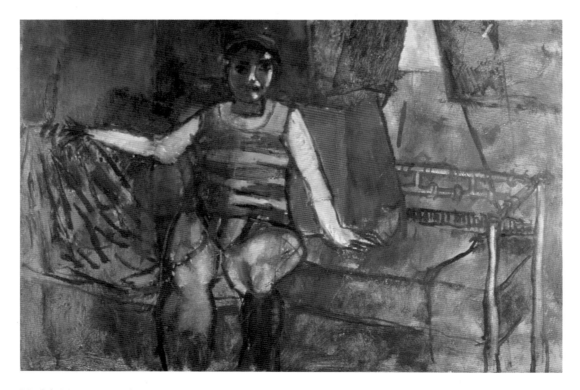

Model, 30" x 20", oil

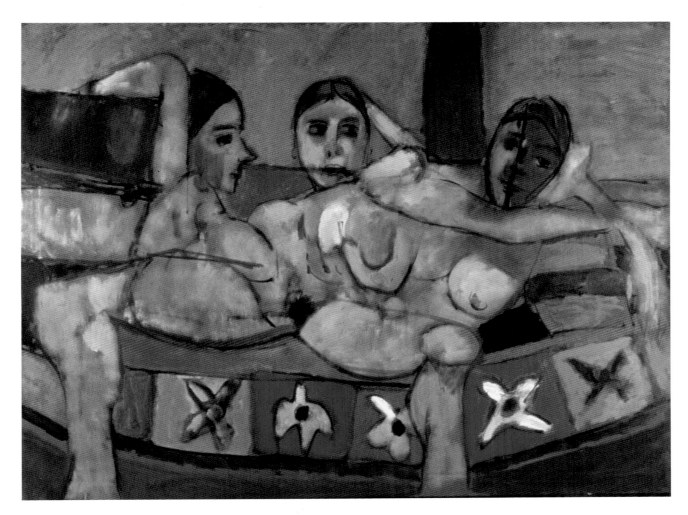

Models, 60" x 40", oil

Martin Mull

My training is in art and my shows are an art. Ninety-nine percent of what I really do is visual art. The other stuff has all been a fluke.

It has been a bit frustrating to be lumped into categories with actors who paint. When I hear, "Oh you're another actor who paints," a shiver goes down my spine. I realize that is the most banal, most elitist feeling I could possibly have but that's how I look at it.

I received my Bachelor's degree in Fine Arts from the Rhode Island School of Design. The first three years of school were in Rhode Island and the fourth year was in Rome, part of the school's European program. I stayed in Rome and got my Master's in Fine Arts. I also taught drawing and painting.

I've never stopped painting pictures. I just couldn't make enough money as an artist to live. There was this gold mine called show business that was not that far afield from the visual arts.

It's very important that my pictures have a certain silliness to them because it disarms the viewer. What I'm really doing in these pictures are puerile kinds of things. The exploration of time and space is what pictures are about. It's making space, making magical space. To do that in a strictly geometric way or a strictly classical approach, without the silliness, would be tedious.

To set up situations for my paintings I take anywhere from 75 to 250 photographs and then start compiling information from them. I make a drawing that becomes a composite of all the different parts. I start the process of painting with an air brush.

You can get big washes or fine lines. Then, you mask off certain things. I try to do as little masking as possible because I don't like the hard edge. What I'm doing in all those pictures is playing with the concept of depth and feel.

Bad Dog, Good Carpet, 24" x 19 ½", oil on linen

Martin Mull was born on August 18, 1943, in Chicago, Illinois. He was graduated from the Rhode Island School of Design, a painting major.

He got his start in show business making comedy albums. That soon led to the part of Garth Gimble on TV's offbeat spoof of soap operas, "Mary Hartman, Mary Hartman." He then starred in the nightly syndicated series, "Fernwood Tonight."

Next was "America 2Night," a tacky talk-show spoof featuring mythical celebrity guests as well as real ones.

He has been a frequent guest host on "The Tonight Show" and has appeared as a guest on such shows as "The Merv Griffin Show," "The Chevy Chase National Humor Test," and "The Hollywood Squares." He performed on three one-hour specials for the BBC in London and received an Emmy award for his work on "The Great American Dream Machine."

His film debut was in *FM*, followed by a starring role in the Paramount film *The Serial*. He is also a screenwriter.

His paintings have been shown in various galleries. He currently lives in Malibu, California.

Kim Novak

I won a scholarship to the Chicago Art Institute and went there for three years. I was very happy. We mostly worked in pastels and charcoal.

In Hollywood you're a collage but with art it's your own creation.

I want the viewer to participate in the picture. I hope that my pictures call for participation.

Art helped me through the tough days of Hollywood. I was able to get out my feelings and make it through another day. It was a way of expressing myself that they couldn't take away from me.

The need to paint comes upon me when I feel frustrated.

In acting it all gets so diluted; in painting there is no compromise.

Regarding Fallen Monarch

This is a picture of my father. The scene behind him is from the Petrified Forest. I see it as a man whose feelings are trapped, petrified. He's unable to let out all his feelings, his passion, so it dies.

Born Marilyn Pauline Novak in Chicago, Kim Novak started modeling as a teenager and was chosen to tour the country in an advertising campaign for a refrigerator company as "Miss Deepfreeze." The tour ended in California where she was discovered and signed to a long-term contract by Columbia Pictures in 1953.

Her first film was opposite Fred MacMurray in *Pushover*. She became a star in her second movie, *Phffft*, a comedy that starred Judy Holliday and Jack Lemmon. She went on to make many motion pictures including *Picnic*, *The Eddie Duchin Story*, *Jeanne Eagles*, *Pal Joey*, *Vertigo*, *Bell, Book and Candle*, and *The Adventures of Moll Flanders*.

She retired from films for a time but returned in the late 1970s and made, among others, *Just a Gigolo* and *The Mirror Cracked*. She also made a special appearance on the TV series "Falcon Crest."

Ms. Novak lives with her veterinarian husband, Dr. Robert Malloy, in Carmel, California, and on a ranch in Oregon, where they breed llamas and farm animals.

Fallen Monarch, 20" x 20", oil

Jeff Osterhage

I started drawing cartoons when I was a kid in Detroit. When I was in high school, I thought I wanted to be an architect; I studied it a little in college. But acting took first place after I starred in a few college plays.

After about six years in Hollywood, I saw Pat Nagel painting on TV. I felt that I could paint too. Nagel has had a great influence on my painting but I don't want to imitate him the rest of my life. I want to keep experimenting and try new styles.

I like acrylic; it dries flatter and quicker. I can finish a painting in three days.

Like most men, I'm fascinated by women and feel very comfortable painting them.

I know a piece of good art by how it makes me feel. It's like a good-looking woman. If I'm drawn to it and want to keep looking at it over and over I know it's good art. It's an emotional thing. It grows on you, like loving someone. The same thing goes for acting. There are some actors or scenes that I love to see over and over. That's art.

When I create a painting, write a screenplay, or act in a movie, if I do good work, I feel great. It's the creative high you get by knowing you did a good job.

Jeff Osterhage was born on March 12, 1953, in Columbus, Indiana. His interest in acting began in high school when he landed a small part in *A Midsummer Night's Dream*. He continued to pursue his acting interests at Western Michigan University and studied privately with an acting teacher.

In 1977 he drove to Los Angeles and immediately began knocking on casting doors without appointments and without an agent. A casting director liked Jeff's acting ability and he was introduced to an agent.

Soon he won the lead in a CBS pilot series with Morgan Fairchild. The pilot never aired but it led to his first movie of the week, *True Grit: A Further Adventure*. This led to other movies such as *The Sacketts*, *Legend of the Golden Gun*, and *South of Reno*. In 1989 he played the lead in "The New Dragnet."

Jeff is an accomplished horseman and drummer. He has never married but has an eight-year-old daughter from a previous relationship.

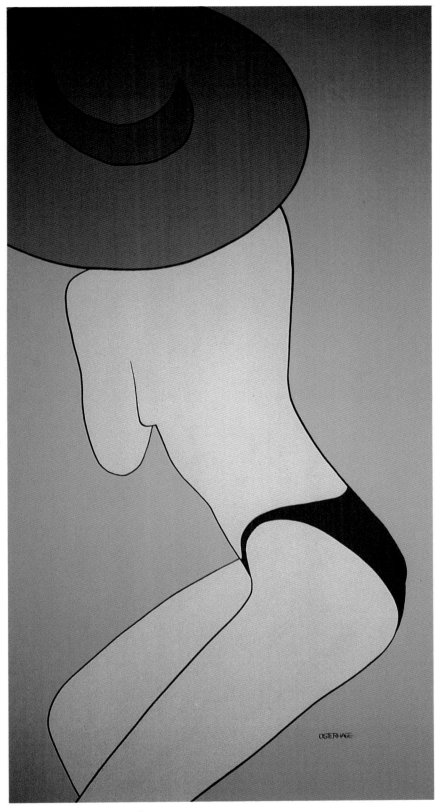

Untitled, 24" x 48", acrylic

Jack Palance

I never trained formally as an artist but I was always around art, especially when I lived in Europe. I lived there for almost fifteen years: Switzerland, Italy, France, and England. There were so many wonderful artists working there in those years.

I like the work of Van Gogh, Picasso, and Rembrandt—all the masters. Each style is interesting. People sometimes say to me, "If you want to have

shows and sell painting then you must develop a style and stay in it." Well I find that very boring, doing the same thing over and over again. Henry Miller was also a good painter and he wrote a wonderful little book about just that. They criticized him for not painting the same theme. The title of the book was Paint What You Like and Die Happy. *I want to die happy.*

Why do I paint? Because I enjoy doing it and I don't care if anything happens. As far as selling is concerned, that's something else. I'm not really interested in that. I have a studio in Pennsylvania and I do a lot of painting there. Good or bad, it seems vital when you are doing it.

Acting is my major profession and painting is something I'd love to be able to do well. Even when I don't do it well, I'm still having fun. If anyone doesn't like it they can go to hell.

With acting, how many roles can you do a year? One or two good roles if you're lucky. With painting, I can do four or five paintings in a week and I'm the boss and the audience too. But the bottom line is, I have fun doing it!

Jack Palance was born the son of a coal miner in Latimer, Pennsylvania, and worked briefly in the mines before turning to professional boxing. After distinguished service in the Air Force in World War II, he turned to acting.

He replaced Marlon Brando on Broadway in *A Streetcar Named Desire* and then played Cassius in *Julius Caesar* at the Shakespeare Festival. Soon he made his way to Hollywood and began a long film career.

Palance has been one of Hollywood's most famous villains for many years. He won Oscar nominations for *Sudden Fear* and *Shane*. Among his other films are *The Silver Chalice, Batman, Oklahoma Crude, The Professionals, Attack, Kiss of Fire, Young Guns, Bullet for Rommel, The Big Knife, Barrabas* and *City Slickers*.

On television he has appeared as the host on "Ripley's Believe It or Not," was in the series "The Greatest Show on Earth," and appeared in the TV movies *Dracula* and *Dr. Jekyll and Mr. Hyde*.

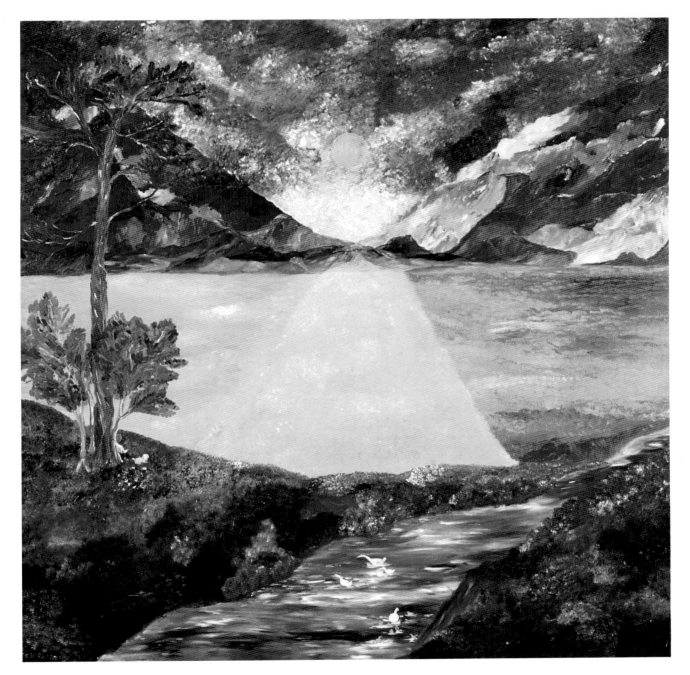

Jack's Fireplace, 29" x 30", oil

Slim Pickens

Slim Pickens developed an early interest in art while working on his family farm. Growing up around horses and cattle he naturally chose them as subjects.

Originally he started doing sketches and watercolors and later moved on to oils and sculpting.

While in the air force he was injured and was sent to a hospital in Chicago. While recuperating he met the Director of the Chicago Art Institute, Fabin Kelley. Mr. Kelley encouraged Slim to work with sculpted figures. He was later offered a scholarship to the Chicago Art Institute but he declined it as his interests were still with the rodeo. That was as close as Slim ever got to a formal art education.

While he was in England making Dr. Strangelove, Slim began to paint scenes from the Grand National of horses jumping.

During the 1970s, while working on a film in Jackson, Wyoming, Slim spent most of his spare time visiting art galleries and he soon became convinced that he wanted to sculpt again. His friend, artist Charlie Beal, was very impressed with Slim's talent and encouraged him to work in wax and bronze.

Slim's talents came to him naturally. His familiarity with animals showed; he was intensely attentive to detail. He was pleased with his sculpture and was satisfied that he could work in any medium he chose but never fully immersed himself into his art work. His busy schedule would never allow it. Slim promised himself that when he retired from the picture business he would work full-time on his art. Unfortunately, Slim passed away before he retired.

—Maggi Pickens Wittman

Slim Pickens became a movie actor after riding the rodeo circuit for eighteen years. He was discovered in 1950 by Warner Brothers director William Keighley and was invited for a screen test. "Me, an actor? You must be out of your mind," said Pickens.

He was persuaded and won a role in an Errol Flynn western called *Rocky Mountain*. He followed this with appearances in more than twenty films in the Rex Allen westerns at Republic Studios. His big break came when he was spotted in *The Outcast* and signed to do *One-Eyed Jacks* with Marlon Brando and Karl Malden.

Pickens appeared in over seventy-five motion pictures and one-hundred-and-fifty TV shows. Among his more notable films are *Dr. Strangelove*, *Major Dundee*, *In Harm's Way*, and *Honeysuckle Rose*.

Slim Pickens was diagnosed with a brain tumor in 1982 and passed away on December 8, 1983, in Modesto, California.

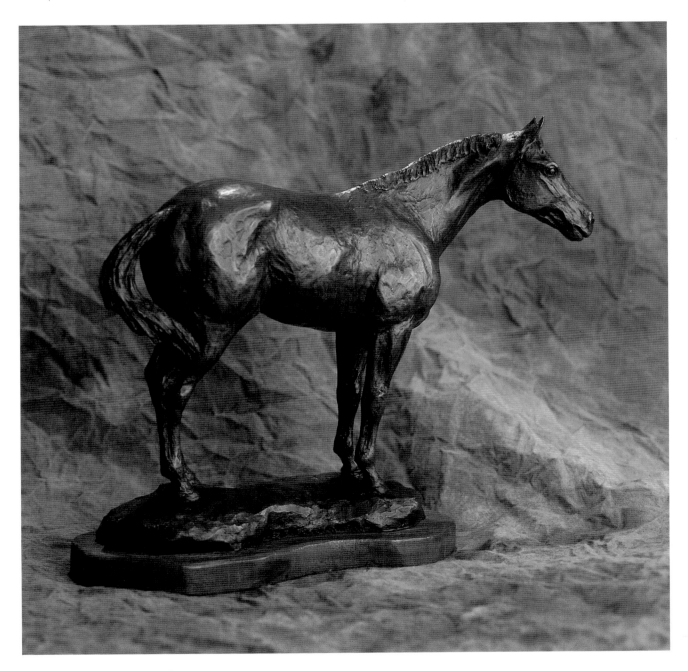

Red Cent, 10 1/2" x 12 1/2", bronze

Eve Plumb

It's great to be able to sit down and accomplish something while you're waiting for Hollywood to call.

I've gotten to the point where I like my artwork enough to show it to people and not even worry whether or not they like it.

I try to capture a moment in time, its hard essence.

The old masters' ability to capture textures and light truly amazes me. What we call photo-realism was their way of representing their world. I also admire the impressionist and "plain air" movements. The paintings are so vibrant and breathtaking.

Eve Plumb was born in a hospital across from Disney studios and baptized in a movie theater. She was six years old when a children's talent agent convinced her mother to take Eve on a commercial audition. She got the job. Eve had acted in many more commercials and television shows when, at ten years old, she won the role of Jan Brady in "The Brady Bunch," which she would play for the next five years.

As high school was ending, Eve was cast in the film *Dawn: Portrait of a Teenage Runaway*, a gritty departure from Jan Brady. Several other television movies followed including *Secrets of Three Hungry Wives*, *The Night the Bridge Fell Down*, *Little Women*, and a sequel to *Dawn*, *Alexander: The Other Side of Dawn*.

The continued popularity of "The Brady Bunch" has led to Eve reprising her Jan role in *The Brady Brides*, *A Very Brady Christmas*, and *The Bradys*. She appeared in the film *I'm Gonna Git U Sucka* and has performed and written comedy at the Groundling Theater in Los Angeles in such shows as "Your Very Own T.V. Show" and "Girl's Club."

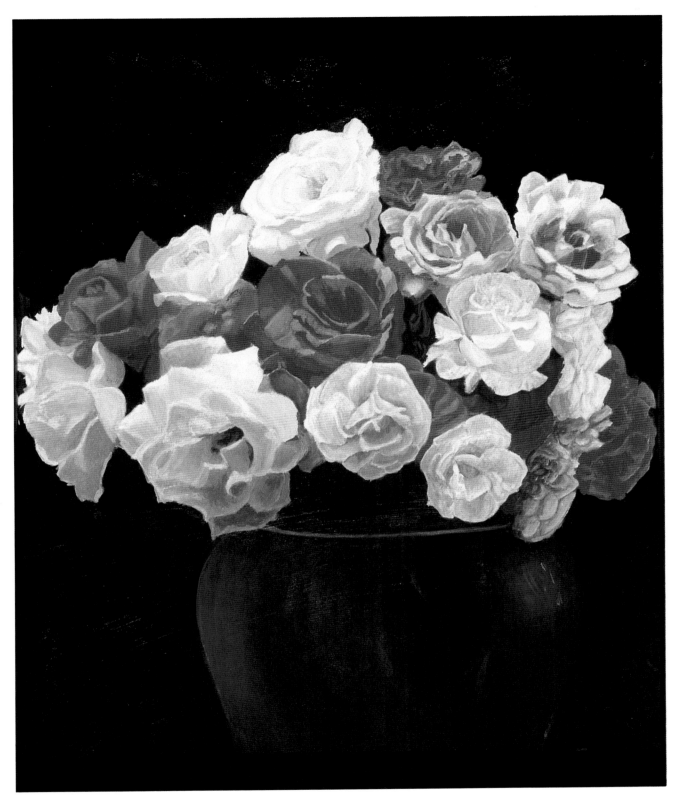

Vase of Roses, 16" x 20", acrylic

Anthony Quinn

I steal from everybody. Picasso stole from everybody. Modigliani stole from everybody. Mr. Michelangelo stole from the Greeks. Mr. Da Vinci stole from Giotto. Rufino Tamayo stole from the Mayan civilization. There isn't one man that doesn't steal. Let me tell you: a big talent steals, a small talent borrows. I steal.

It has been said that two people paint a picture—one with a brush and one with a hammer. You hope that some day, if you're lucky, you can find the hammer within yourself.

I'm not going to copy Mr. Picasso's toilet paper because that won't help me as a painter. I might copy the brush that he used. I might copy his palette. But I'm not going to copy the fact that he ate spinach and think that spinach is going to make me a better painter.

Painting the face as a picture is not difficult. It's rather easy. But to paint the essence of what that face is or what it represents to me—that's going to be the next step."

As a young student in Poly Technic High School on the East side of Los Angeles, Anthony Quinn was acting, directing, and writing plays. In 1935 he earned fifteen dollars working with Mae West in *Clean Beds.*

After that he worked in loincloths and bearskins, and played an assortment of gangsters before appearing in Cecil B. DeMille's *The Plainsman.* He divided his time between films and the stage during the next few years, heading the Chicago company of *A Streetcar Named Desire.*

His motion picture credits are numerous, from Marlon Brando's broodingly violent brother in *Viva Zapata!*, for which he was awarded an Oscar, to the gentle giant of *La Strada* for Federico Fellini, to the role of Paul Gauguin in *Lust for Life,* for which he won his second Academy Award. He directed *The Buccaneer* for Cecil B. DeMille and joined Laurence Olivier on stage in *Becket.*

Then along came *Zorba the Greek,* a role tailor-made for Quinn. Nineteen years later, he starred on Broadway and on tour in a musical version, *Zorba.*

Anthony Quinn has been awarded a multitude of awards during his long career but still lives by the philosophy expressed when he picked up his Academy Award in 1956: "Acting has never been a matter of competition to me. I am only competing with myself."

Art plays a lasting and significant role in his life.

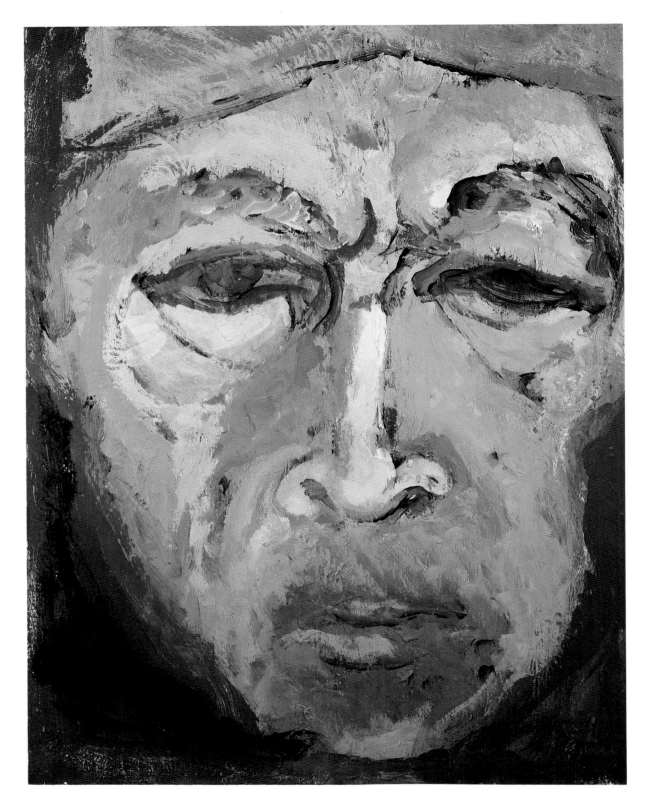

Glance in the Mirror, 19" x 25", oil

Cyrenaica, green marble

Mela, 27" x 37", oil

Desert Lady, 12" x 24" x 14", travertine marble

Tommy Rall

I have always loved the act of painting: the brush stroke, the line the pen makes when drawing, the quality of the paint surface, the ever changing light and dark, forms evolving into new forms, the way objects occupy space, and most important, the way our thoughts occupy space.

I approach each new work with a fresh eye. Whether figurative or abstract, I try to let the knowledge I have come into play naturally, without rules becoming a straitjacket. My work has similarities naturally, because it is coming out of my experience and emotion.

Never have I thought of painting as a hobby. I don't believe drawing, color, design, and content to be a simple thing. It should appear spontaneous and accomplished with ease, as with dance, singing, or acting. All the training and years of experience it takes to appear effortless is not simple. I want to make the spectator see the world not his way but my way, a different way, if only for a few minutes.

I first studied painting with Sueo Serisawa in Los Angeles. At the advice of Rico Lebrun, I studied drawing for two years at the Chouinard Art Institute under Herbert Jepson. I continued my studies at the Art Students League in New York.

Tommy Rall first appeared in vaudeville at the age of eight. His first New York appearance came at the Metropolitan Opera House as a member of the American Ballet Theater. He was a soloist and principal dancer with that company for five seasons.

His Broadway shows include *Look, Ma, I'm Dancin'*, *Small Wonder*, *Miss Liberty*, and *Call Me Madam*. He received the Outer Circle Critics Award for Best Supporting Actor in a Musical for *Juno*, a musical version of Sean O'Casey's *Juno and the Paycock*. He co-starred for a year and a half in the hit Broadway musical *Milk and Honey*.

In Hollywood he had featured roles in many films including *Seven Brides for Seven Brothers*, *Kiss Me Kate*, *My Sister Eileen*, and, more recently, in *Dancers* and *Pennies from Heaven*.

Mr. Rall made his operatic debut in Boston in the title role of Massenet's *Le Jongleur de Notre Dame*. He also had leading roles with the Opera Company of Boston, the American National Opera, and the New York City Opera.

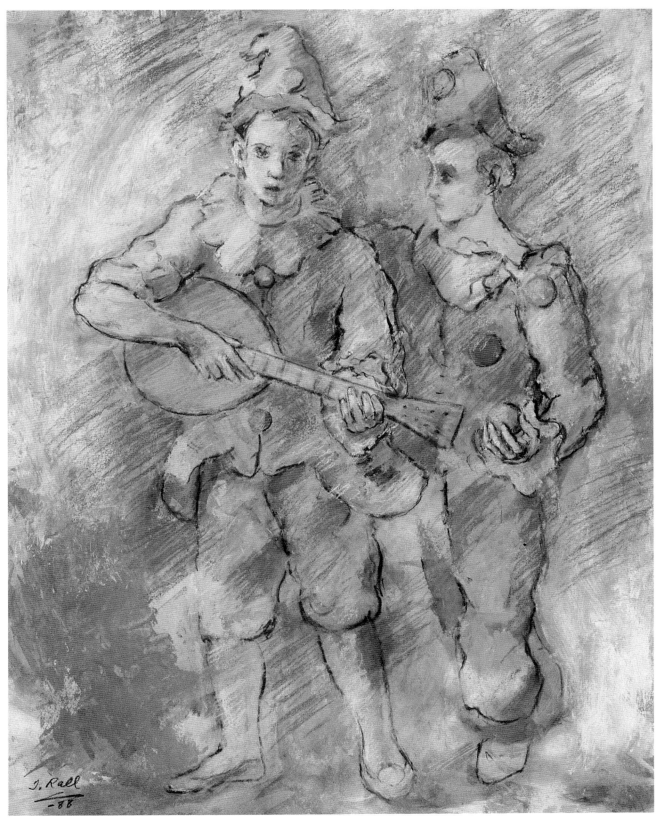

The Performers, 23" x 28", mixed media

Robert Redford

I started painting because it was a way of translating what I saw and what I felt. It was an escape. It soothed anxieties, anger, and frustration. It was wonderful company.

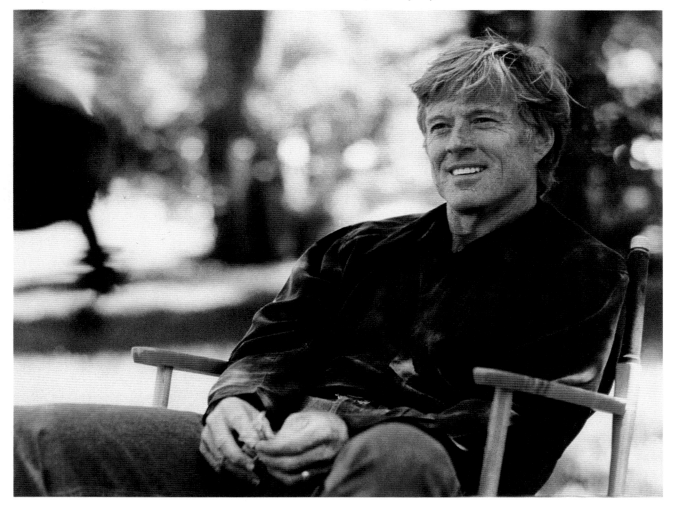

Robert Redford attended the University of Colorado on a baseball scholarship before leaving to study art in Europe. When he returned to the United States, he entered Pratt Institute in Brooklyn to study stage design. An instructor suggested that he enroll in the American Academy of Dramatic Arts to acquire a familiarity with the stage from an actor's point of view. By the time he left the academy, he was committed to acting.

His first Broadway acting assignment was in 1959 in *Tall Story*. In 1961 he made his first film, *War Hunt*. Later in 1961 he had his first starring role on Broadway in *Sunday in New York*, shortly followed by Neil Simon's *Barefoot in the Park*.

Redford's motion picture career blossomed with *Inside Daisy Clover*, *The Chase*, and *This Property Is Condemned*. Many films followed including *All the President's Men*, *Butch Cassidy and the Sundance Kid*, *The Way We Were*, *Out of Africa*, and *Havana*. He received an Oscar nomination for *The Sting* and won a Best Director Oscar for *Ordinary People*.

In 1981, Redford founded the Sundance Institute in Utah. Not a studio or a production company, it aims to nurture filmmakers by creating a certain consciousness in an environment where they can develop their skills. Redford also created the Institute for Research Management, which sponsors conferences and encounters on a wide variety of environmental issues.

Untitled, 12" X 24", pen and ink wash

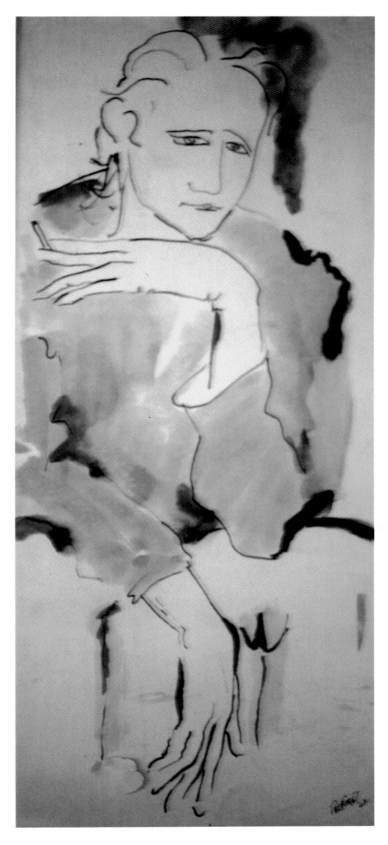

Duncan Regehr

I think that it's all sort of one vision in the long run. What happens when you write, act, or paint? There's a through line in all of those. If you're allowed to use the tools handed to you to express your vision, then you must do it.

I'm ultimately fascinated by human beings. Every moment that you're awake in the day you're studying and filing things away for later use.

I've had brushes in my hand since I was a child. My father thrust them at me and just naturally assumed, since I was his son, that I'd be talented. That early encouragement placed no limitations on me and my work. Art is only an explanation of an experience. If I could have said it in words I would've spoken it to you.

Carbon Faerie, 18" x 24", colored pencil

Colored Rain

For awhile she floats by with everything in place:
Cartoons and Spring are filed together under
Volcano and Soaring Hearts
They change flight with decaying totems or threat

Because she is never the same
You ponder the force behind, and why
It does not change or sleep

Now she bids for colored rain
From golden deserts that were seas once
Where fossils capered before suspension
Before limestone
Before carbon faeries in the petrified forest

It could never be right here that you found fantasy
Curated among molecules
The spirit had to fall dried out
Shaken and withered by stories

All your scattered colors splash down
Hell-bent, through mud and the sediment of others
Settling
For comfortable cocoons in bedrock

the stone prince

Like the laughing wind that cast you
You have found what you wanted
By losing your way

So
You are the stone prince again
Gloating under camouflage
Bearing feathers in your cap
Stolen flowers from the tomb
Decorated
Like an ancient vampire, leaking at the
 seams
You tread upon hourglass shards
While draining the poet's urn

Yes
You are stone again
A rising pyramid
Made from the great and small
Of other stones, that were
Grains and glass, and then stone again

Yes
You are the shrine
Dead, before your death
For the hyena wind devours the standing
Then regurgitates in the barrens
Where fallow dunes inter each other

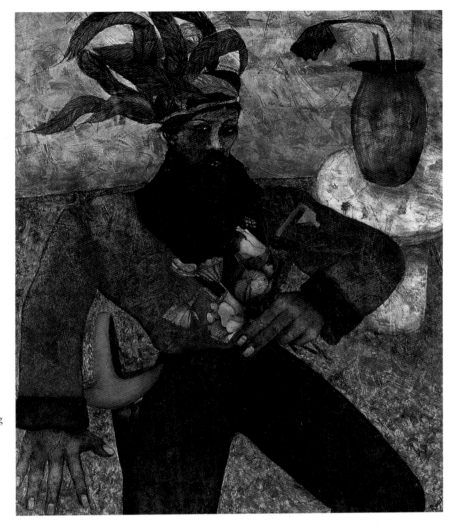

The Stone Prince, 30" x 36", oil

Raised in Victoria, Canada, Duncan Regehr decided to become an actor after having first experimented with figure skating, boxing, and painting.

His performing career began in Canadian regional theaters and moved on to the Ontario Shakespeare Festival. He came to Hollywood in 1981. There he appeared in a number of TV mini-series such as *The Blue and the Grey*, *The Last Days of Pompeii*, and *My Wicked, Wicked Ways*. More recent theatrical motion pictures have included *Monster Squad* and the title role in the Disney film, *Earthstar Voyager*. He played Pat Garrett in Gore Vidal's "Billy the Kid."

On The Family Channel, Regehr plays *Zorro*.

Off screen, Regehr devotes as much time as possible to writing and painting, working primarily in oils. He also collects European, Canadian, and African art.

He lives with his wife Catherine in Washington state.

As anyone would tell you who dabbles in art and also in show biz—art is relaxing. It's like flying or playing golf. You can turn off the telephones and escape. Even if you're not good you feel like you're part of the artists' colony.

Art is the only thing in the world that I can enjoy without getting bored. One of my favorite pastimes is going to an art gallery. It's always been that way even before I knew what I was looking at. People in show biz like to think of themselves as being in the arts but I believe that art in its purest form is exhibited by sculptors, painters, and the like.

Burt Reynolds

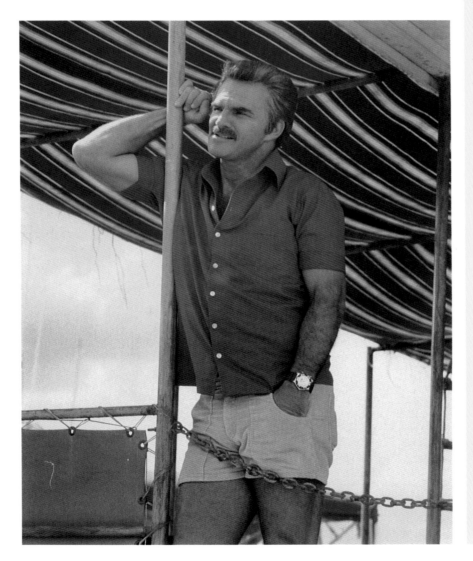

Burt Reynolds was born and raised in South Florida, where he showed promise as a football player. An automobile accident prevented him from becoming a professional athlete, so he turned to acting.

His first starring role on the stage was in *Outward Bound*, which won him the Florida Desk Award. His first big role on television was in a series called "Riverboat." He made his Broadway debut in *Look We've Come Through*. The turning point came when he appeared in *Deliverance*. His performance made him a star.

After that came such films as *Shamus*, *The Longest Yard*, and one of his biggest hits, *Smokey and the Bandit*. In 1976 he directed *Gator*, the first of four films he would star in and direct.

He starred on TV as "Dan August" and made numerous appearances on "The Tonight Show."

In 1978 The Burt Reynolds' Jupiter Theater opened in his hometown of Jupiter, Florida.

Burt Reynolds holds the record for being the movies' number one box office draw for five consecutive years. He recently won an Emmy for his performance on the television comedy series "Evening Shade."

Reynolds is married to actress Loni Anderson and they have a son, Quinton Anderson.

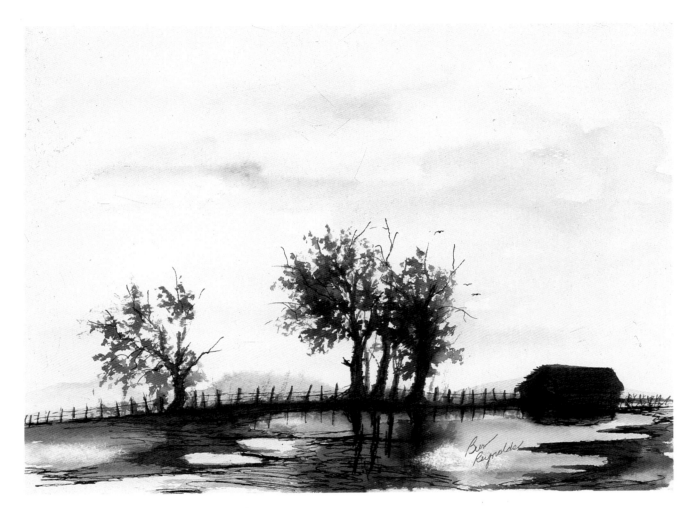

Georgia Landscape II, 18" x 14", charcoal

Painting is the second most important thing in my life.

In 1980 James Cagney sent me to study with Sergei Bongart in Roxburg, Idaho. Sergei loved my sense of color and composition but hated my drawings. He made me promise that on returning to Los Angeles, I would study drawing.

I enrolled at UCLA and studied drawing with Mark Stickland for three years. I wanted to be able to draw exactly what I saw. I could then draw what I wanted you to see. With Sergei and Mark's approval, I started to paint.

The alienation that starts in society came into my life with great force. It was multiple sclerosis.

Art has been a life line to all my feelings.

At first, my paintings were of solitary people, isolated or turned away. Then they became realistic: my friends, children, and pets. I did MIAs, hostages, and angry abstracts followed by still lifes, clowns, and romantic florals.

Now I've started to sculpt. I don't know where I'll go with my painting next, but I do know the meaning of my art work still resides in the viewers response to it—not in my intentions—although a mutual feeling is often present.

In a very small one-room studio in Pasadena, Mark took away all my supplies. He handed me one thing at a time: a twig, some ink, a few pastels, tubes of acrylics, gesso, a sponge, and I did Sunshine on My Shoulder. I learned the most wonderful thing. All my experiences of perfection were gone. Great relief and freeness resulted by the end of that painting.

The mistake we all make is in thinking that certain standards exist and that we must meet these standards in order to establish our place in the universal hierarchy. But hierarchies in artistic expression are not valid nor universal; they're personal. Therefore, every artist is a gifted king or queen and his or her work is of the highest quality. And that's the truth!

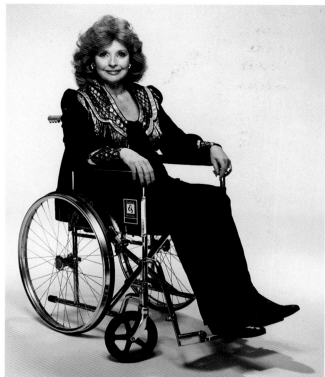

Madlyn Rhue

Born Madeleine Roche in Washington, D.C., Rhue always wanted to be an actress. After Los Angeles High School and Los Angeles City College, she went to New York to study at the Curt Conway Studios.

She played summer stock for several years but her big break came when she appeared in *Two for the Seesaw* at the Civic Playhouse in L.A. "Cary Grant loved my screen test," says Rhue, "because I listened, and from that I was cast with him in *Operation Petticoat*." She has appeared in numerous films and televison shows. Among her movies are *The Kiss, The Miracle* with Carroll Baker, *The Ladies Man* with Jerry Lewis, *A Majority of One* with Alec Guiness and Rosalind Russell, *It's a Mad, Mad, Mad, Mad World*, and many others.

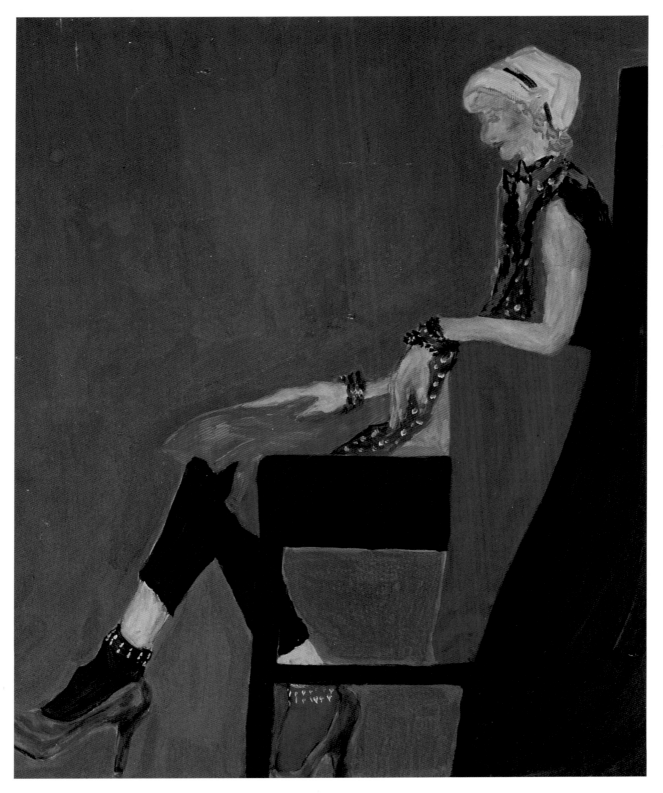

Whistler's Bimbo, 16" x 20", oil

I started drawing and painting when I was very young. I went to the Philadelphia Graphic Sketch Club, a fine philanthropic art institution, from the age of nine to about seventeen. The emphasis was academic so I had a good background in drawing. It didn't dawn on me until much later, by the time I was already a serious actor, married, and father of several children, that I was really an expressionist.

For the last twenty-five years or so I have painted with much more of an inner direction. An artist has something in him that has to be expressed. The way he expresses himself on canvas or paper is relative to his inner life. I believe in a spiritual sense. The artist has very little choice in the matter. No matter what he does, what comes out is really him in certain periods of his life. It is constantly changing.

Peter Mark Richman

Acting has never been enough for me. I think it's terribly limiting, so in the time I have in between acting jobs I paint and write. Painting and writing seem to help me to release whatever it is that I need to release. That's the fascinating part of this whole business. As an actor you never know what is going to happen tomorrow. It's the same in painting. The difference is that as a painter you are your own boss. You don't have to talk to a director or a producer about what tube of paint to use.

I have been called an expressionist. Whatever I'm called, I am an instinctive, intuitive, emotional painter with a particular temperament that corresponds to my inner nature. I am the same as an actor and, I suppose, as a person. I basically paint the same way I did when I was ten years old except that it is more varied and my technique is more sophisticated.

I am not an intellectual painter. When I lose all thought and work subconsciously and freely, not knowing how I accomplish certain effects or variations in color, then I feel I am most in touch with my inner life. When that happens, hours can go by and their passing is unfelt because I am so completely submerged in my work. To me these times are the most creative and fulfilling.

When I paint, getting started and then knowing when to stop is a big problem. I conclude work on a painting when I am satisfied, when it pleases me, and when I feel that I have accomplished best what I can do. There are some paintings that never seem to be finished.

Born and raised in South Philadelphia, Pennsylvania, Peter Mark Richman began his training as a young boy, studying for seven years at the Philadelphia Graphic Sketch Club. He was graduated from the Philadelphia College of Pharmacy and Science with a degree in Pharmacy. After managing a pharmacy for a year he joined a summer stock company and played opposite a young actress who was soon to become his wife.

Richman's first New York appearance was in Calder Willingham's *End As a Man*. He also appeared on Broadway in *Masquerade*, *Hatful of Rain*, and in 400 performances of Edward Albee's *Zoo Story*. William Wyler, the noted director, brought him to Hollywood to appear in *Friendly Persuasion* with Gary Cooper. He has starred in many films including *The Strange One*, *The Black Orchid*, and *The Dark Intruder*. On TV he stared in "Cain's Hundred" and has done over 500 guest appearances. In the first four years of "Dynasty," he was seen as attorney Andrew Laird. His TV movies include *McCloud*, *Dempsey*, and *City Killer*.

Richman's art is in the permanent collection of the Crocker Museum in Sacramento and at the University of the State of New York. He and his wife Helen have five children.

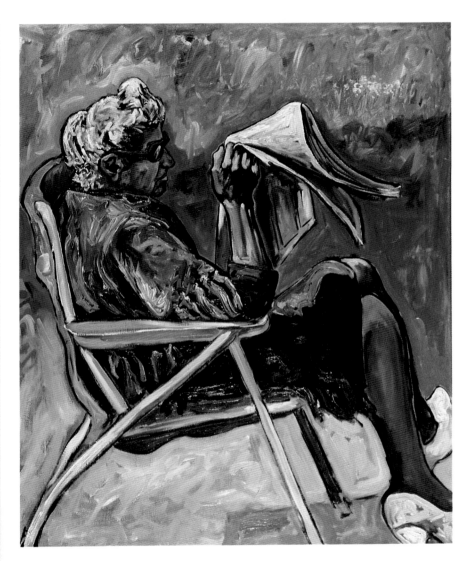

Old News, 31" x 37", oil

Edward G. Robinson

Acting and painting have much in common. You begin with the external appearance and then strip away the layers to get to the essential core. This is reality and that is how an artist achieves truth. When you are acting, you are playing a part, you are being somebody else. You are also, at the same time, being yourself.

There is no such thing as a happy or unhappy picture. Look at it from another point of view—that of the theater. Is The Lower Depths *unhappy? No, because it concerns itself with mankind. To probe into the problems of man is not unhappy. The probing is what happily sets man apart. Unhappy pictures are shallow pictures—pretentious, false, ugly. Unhappiness is not to be confused with somberness.*

Paintings never really belong to one of us. If we are fortunate, as I have been, we are allowed at most a lovely time of custody.

I have not collected art. Art collected me. I never found paintings. They found me. I have never even owned a work of art. They owned me. What people call my collection is this group of masterpieces that collected each other and then very kindly allowed me to go into debt to pay for them.

Sometimes late at night, when the house is quiet and the last guest has gone, I go into my living room and sit down among these quiet friends. We study each other gravely and, I hope, with mutual pleasure. I sit there and think that if man could create this beauty, if he could produce the life, form, and color that make the magic of these canvases, and do it from tinted earth, stirred with insight, passion, and faith, then there is hope for us all.

We too are made of earth.

Like many actors, Edward G. Robinson got his start in show business on the stage. He played men of so many different nationalities that he was known in New York theatrical circles as the "League of Nations."

When he got to Hollywood he immediately began to play despicable, tough, gangster-like parts, the total antithesis of what he was like in real life. Friends considered him a sensitive and generous man. He was also a fervent art lover and collector.

The film that brought him to international attention was *Little Caesar*. Many films followed including *Barbary Coast*, *Dr. Erlich's Magic Bullet* (one of his personal favorites), *Confessions of a Nazi Spy*, *Double Indemnity*, *All My Sons*, *Key Largo*, *The Ten Commandments*, and *Soylent Green*, his last film.

Portrait of Sam, 24" x 30", oil

I always remember painting or drawing. Mostly, I was interested in representing form and figure. Later on, after I immigrated to Brooklyn, New York, I was inspired and encouraged by a wonderful sculptor, Ron Mehlman, who taught at my high school. I also took figure drawing classes at the Brooklyn Museum.

I always believed that acting and painting go together. I find it very normal (for use of a better word) that if you are a good actor you should be able to paint or draw something because a lot of acting preparation is visually based in terms of form, color, and emotion. The two must somehow connect. I think cinema and art work very closely that way. I love art that makes me look longer at it than I should.

Franklyn Seales

Artists who have influenced me? Well, they are too numerous to mention. Anyone who truly creates should be given attention. They may be able to help me find my own way.

About his pen and ink work, Seales said: I wanted to concentrate on the rapidograph. I found that pen and I fell in love with it. It created the lines that didn't treat the body as an inhuman thing. I found that I could make something human out of something that was angular. The human eye is taken along one course and then along another.

I also wanted to outline the industrial age—machinery, wheels, robots—in a way that made them human. I wanted to create art that touched people and made them think.

I'm a color freak. I love color. I admire the way that Matisse, Picasso, and Rembrandt used color. I'm interested in a lot of color and a lot of vibrancy. If you see a field of different kinds of flowers, it is mesmerizing. You want to look at it all the time and see how they change: the greens, the reds, the blues, the yellows.

I'm not interested in painting reality. I'm interested in representing reality in color, form, and line. Maybe I will pursue that medium later in life. I'll try oils. I always found oils messy. I'm also a little impatient with them because they take so long to dry. I like to put many colors on top of one another and that is difficult to do with oils.

When I run out of ideas I will stop but I don't think that will ever happen. I'll paint as long as I'm here.

This is my dream: to get better, to buy an old cottage somewhere, have some dogs, paint, and live out the rest of my days happy.

I would like you to perceive my art as something of nature that can heal with its color, movement, and simplicity.

My art is variable. I think periods are bullshit.

Somewhere I think God is watching over me in a singular and complex way because of the way things have come together.

Ballgame, 20" x 15", pen & ink

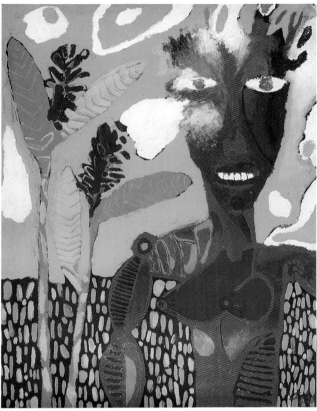

Lena and Some Friends, 30" x 40", acrylic

Franklyn Seales was born on Villa Bay, an island of the former British colony of St. Vincent. As a young boy, he studied with Ian Robertson, a colorist and landscape artist, and West Indies artist O.D. Brisbane. He was greatly influenced by discoveries experienced during hours of exploring his island's beaches and caves. He drew inspiration from stone carvings of the local Carib Indians.

In 1967, fifteen-year-old Seales moved to New York where he studied with Ron Mehlman of the Brooklyn Museum. He was awarded a scholarship to Juilliard and there studied with John Houseman. He was graduated from Juilliard in 1974 with a B.F.A. and an M.F.A. in theater. He decided to move to Los Angeles and pursue a career in acting.

On stage he is known for his Shakespeare and has appeared in *Romeo and Juliet*, *Hamlet*, and *King Lear*.

On screen he has appeared in *The Onion Field*, *Southern Comfort*, and *Star Trek: The Motion Picture*. His television roles include appearances on "Hill Street Blues," "Wise Guy," and "Silver Spoons."

In 1989 he returned to New York to concentrate on his art career. Franklyn Seales died of AIDS on May 14, 1990.

Jane Seymour

I paint because I love it. It's for myself, for my pleasure. It gets me away from everything. I paint wherever I go. That's why I use watercolors. I can easily take them with me anywhere. I paint when I'm filming. I paint with my children.

I studied art in school when I was a kid but never trained formally.

It all began when I commissioned Tom Mielko, a local Santa Barbara artist, to do a drawing of my children, Katie and Sean. I donated the painting to a local charity fund raiser. Tom saw a few sketches of mine, thought I had talent, and offered to give me a lesson in watercolors.

I love the work of Renoir, Degas, Chagal, Monet, and Picasso.

The beauty of painting for me is that it's my expression and it hasn't been edited, cut, or changed by anyone else. It's pure me. It's my very own expression. In acting I'm hired to play a character that someone else has created, developed, or edited and I have little control. With art I feel that I have more control; it's all mine.

I love to turn people on to painting, to try it themselves. I offer my paints and suggestions to my friends and we all have a go together. I've turned a lot of people on to painting who didn't think they could do it. That's the fun of it for me. It's very therapeutic and relaxing.

It's also a wonderful thing to do when you have children. I keep a supply of good quality paints, paper, and brushes in the kitchen and my kids and I paint every day after breakfast. They want to; they ask to do it. It's a wonderful way to find out what your child is thinking. By looking at their paintings you can tell who they are, what interests them, and how they're trying to express themselves.

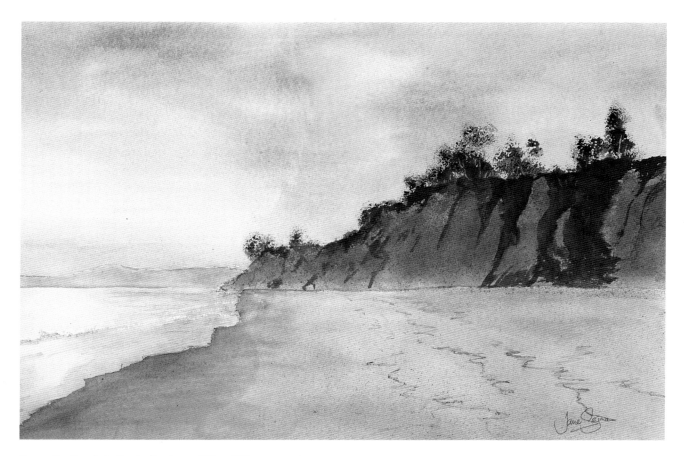

Butterfly Beach in Santa Barbara, 18" x 12", watercolor

Jane Seymour was born in Wilbleton, England. She began training at an early age and was just thirteen when she made her professional debut with the London Festival Ballet. That same year she entered the Arts Educational Trust to train in dance, music, and theater. A performance with the Kirov Ballet was to be her last after she suffered knee injuries.

She then turned to acting. Her film debut was as a chorus girl in *Oh, What a Lovely War*. That led to plays, radio dramas, and more films. Among her motion pictures are *Live and Let Die*, *Somewhere in Time*, and *Battlestar Galactica*.

She has appeared in many television movies: *Captains and Kings*, *Seventh Avenue*, *East of Eden*, for which she won a Golden Globe award, and *War and Remembrance*, for which she was nominated for an Emmy and a Golden Globe. She won an Emmy as Best Actress in a supporting role for her portrayal of Maria Callas in *The Richest Man Alive* and was nominated for another Golden Globe for her performance as the Duchess of Windsor in *The Woman He Loved*.

Ms. Seymour is very active in a number of charities that are dedicated to research, treatment, and prevention of child abuse. Jane, her husband David Flynn, and their two children live in Montecito, California, and, when they are in England, occupy a fifteenth-century country estate near Bath.

All my art deals with whimsy and fantasy.

I never have any idea what I'm going to make. Ideas just pour out of me. I never had any kind of art training at all. When I was very young I got a scholarship to Chouinard. I decided to go study pantomime instead.

Spirit and my work are closely knitted. This summer I spent nine days in a vipassana retreat. I learned so much: that we're really not the body and we're not the mind. It's helping me to cope with life.

Robert Shields

I live in a museum of fantasy, puppets, masks, and dolls. I have my art studio, recording studio, clay studio, painting studio, and dance studio. I'm a complete art factory. Even when I write to someone, the envelope is painted.

It's all part of Merlin energy for me. I really relate to those times. That's why I make castles, dragons, and court jesters. My masks are from many different cultures— ancient Chinese, Asian Indian, and Native American.

The trouble with art is that it is something that you create and then become attached to. I spend about five weeks creating a castle and then I become attached to it. It's beautiful, a magical thing. I don't want to sell it. I have to learn to create something and not be attached to it.

Since the world is an illusion—we all know that—part of art is that you're creating more dense matter, more material things.

I'm way beyond the ego so I'm able to make my art please me and not anyone else. Before it was "Do you like it, do you really like it?" Now, if I like it, that's all that matters.

My paintings, mostly watercolor, acrylic, and airbrush combined, are done with no preconceived vision of the final result. My mind goes where my fingers take me.

I have devoted a great deal of my time to mask making. The Commedia dell'Arte had a great influence on me. It taught me how easily the personality of the wearer could be replaced with a being from another world—a mask has that power. Realizing that the power of masks springs from emotional, non-rational meanings of which people are not even aware, I decided to put my hands in clay and create my own magical transformations.

We all wear invisible masks. We laugh when we feel pain. We say "fine" when we are not. The things we feel for people are sometimes hidden behind concrete masks. Some people succeed in removing these masks. Others never do. The mask defines an emotion and a feeling that has always been an integral part of my work as a mime artist.

Kachina Robots, 19" x 9", airbrush and watercolor

Blue Cafe, 36" x 24", acrylic

Robert Shields didn't talk until he reached the age of four. During these silent years, he was unwittingly practicing for his future career as a mime.

By the age of sixteen, Shields was performing in a traveling circus. This led to a stint at the Hollywood Wax Museum where his skills as a "mechanical" man were honed. He was discovered by Marcel Marceau and was granted the first American scholarship to Marceau's school in Paris. Robert's apprenticeship there was short-lived. He felt the need to develop his own style. He wanted to take mime down from its pedestal and put it in the streets. He chose San Francisco as his outdoor stage and for seven years he was one of the city's major tourist attractions.

In 1972 he met Lorene Yarnell and a new team emerged. They starred in the successful television series, "The Shields & Yarnell Show." In 1984, Robert was awarded a special honor by the International Mime and Clown Association for bringing mime to mainstream audiences. For the past five years, Shields has been performing solo in Japan, China, and Italy, as well as in the U.S.

I saw a man painting out at the beach one day and I said, "If he can do it, I know that I can." So I got my box of paints and just started. Later I took the "Famous Artists Course." I always loved Norman Rockwell's work and he was one of the teachers in the school. I learned all the basics: stretching the canvas, how to underpaint. I read all the books and learned all kinds of tricks.

I paint during those chunks of spare time between jobs. I need to be in the mood to paint.

The Sunshine Girls is a caricature. We were doing a TV show in Miami Beach and these girls came down every day to watch us. Every day the stage manager would say, "Set up the chairs." It was the "club." Some people don't like the painting because they think I made fun of the girls. I saw them as wonderful, adorable, and indomitable. I loved them.

I like a clean palette. It's bright and clear. Some artists like a dirty or muddy palette. That's not for me. I think it's a reflection of my personality, the way I see life.

I love golf. I could play it every day of my life. It has really messed up my painting. There just isn't enough time.

Dinah Shore

Dinah Shore was born Frances Rose Shore in Winchester, Tennessee. She can't remember when she wasn't singing for anyone who would listen. She auditioned for disc jockey Martin Block with a song called "Dinah," got the job, and a new first name.

After graduating from Vanderbilt University, she returned to New York where she sang duets with another unknown, Frank Sinatra. She was heard by Xavier Cugat, who hired her to record with his orchestra. This led to her big break, when Eddie Cantor signed her for his radio show.

Soon after that Hollywood called and Dinah was appearing in *Up in Arms, Belle of the Yukon, Till the Clouds Roll By*, and *Aaron Slick from Punkin' Crick*, a film that she describes as "ever forgettable." During this time she met and married movie star George Montgomery.

In the 1950s, "The Dinah Shore Show" was a big success on television. It was followed by "Dinah's Place" and, later on, by her daily talk/variety show, "Dinah!" In August of 1989, Dinah returned to television with a new series, "A Conversation with Dinah."

Dinah has won many awards throughout her career. Among them are nine gold records, ten Emmys, the Peabody Award, nine Gold Medal Photoplay awards, and the Downbeat Pop-Jazz Award.

Dinah has two children, Melissa Ann and John David.

The Sunshine Girls, oil

Elke Sommer

I can't imagine my life without painting. It delights me when people buy a painting because they're buying something that is mine: my soul, my humor, my sadness, my ability with my hands.

When I do a movie, people tell me where to go, what to do, what to wear. I'm really a tool. But when I'm painting, it's my own thing.

People say I paint sad faces. To me they are faces. Some are pretty, some are ugly, some are fat, some are thin. My people have character in their faces. They're not sad.

For me acting is such an extroverted profession. You're extremely exposed, very visible, especially when you're working on stage. Painting is very introverted, totally quiet.

I have a lot of patience. I work very slowly. I sketch, put in the colors, use the black wash, and then take the black out. It's a painstaking five-step process.

I've been painting since I was a kid. It took a long time for my style to emerge. I think that acting and painting are a symbiosis. I need it because I'm always on the run, performing in the public eye. But when I plunk myself in front of my easel, I can sit there for hours.

Art is totally subjective. If they like Elvis Presley on black velvet then let them enjoy it. If I see a yellow dot on black and it's selling for thousands of dollars, it's not my idea of art. But to someone else, it is art.

My early paintings were done in monochrome. One day I was sitting in my garden and I suddenly became aware of all the colors around me. I saw the purples next to the reds next to the pinks next to the blues—colors I would normally never dress in or paint with. I thought, if God made this, why can't you? I started going all out in color but they're always muted because of the black wash.

My style evolved from monochrome to polychrome. I've been painting this way for nine or ten years. It's a church-window, leaded-glass effect. I like clean paintings—defined, a lot happening—but clean. Someone once said to me, "You do such healthy paintings."

Pool, 36" x 24", acrylic

Elke Sommer was born in Berlin. After graduation, Elke planned to become an interpreter for the League of Nations. In order to perfect her English and earn money, she went to England as an *au pair* girl and studied for her High Cambridge Exams in English.

The Italian film director Vittorio De Sica saw her picture in a newspaper and hired her for a small part in a film. Other roles followed.

After several pictures in Italy, Elke was offered a starring role opposite Richard Todd in *Don't Bother to Knock*. The movie made her a star. Her first American film was *The Victors*. Other films included *The Prize*, *A Shot in the Dark*, and *Lily in Love*.

On television, Elke has appeared in mini-series such as *Inside the Third Reich*. On stage she has starred in and directed *Same Time Next Year* and *Born Yesterday*.

Elke has had over fifteen one-woman art shows in major galleries throughout the world. She is also the author of a book on painting.

She is married to an American journalist and lives in Los Angeles.

Sally Struthers

Art to me is color and life would be colorless without art.

Sally Struthers was born and raised in Portland, Oregon. She attended the Pasadena Playhouse College of Theater Arts, where she won a scholarship as the most promising new student.

Sally worked on numerous commercials, danced on "The Herb Alpert and Tijuana Brass Special," and made regular appearances on "The Summer Smothers Brothers Show" and "The Tim Conway Comedy Hour." She then won the Gloria Stivic role in "All in the Family," which made her a star.

Other television appearances include the movies *Deadly Silence*, *A Gun in the House*, and *Intimate Strangers*, and the series "9 to 5" and "Gloria." She starred as Charlene, a twelve-year-old dinosaur, in "Dinosaurs."

On stage she has appeared on Broadway in Neil Simon's female version of *The Odd Couple* and in *Wally's Cafe*. In films she has appeared in *Five Easy Pieces* and *The Getaway*.

Sally Struthers has won two Emmy awards.

For over fifteen years, Struthers has been the International Chairperson of the Christian Children's Fund. She lives in Brentwood, California, with her daughter Samantha.

Rainbows, 12" x 12", watercolor

Russ Tamblyn

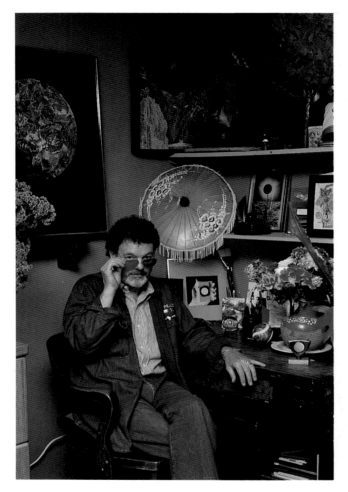

In entertainment, your function is to make the audience's head spin. In art, your function is to make your own head spin.

I really don't like to talk about my work. I remember watching a TV show on art once and there was a panel of artists discussing their work. Each one got up and talked about his reasons for doing what he did. When they came to Bruce Conner, he picked up his brief case, turned it upside down, and out poured hundreds of marbles all over the stage.

Russ Tamblyn was born in Hollywood, California. In 1945, when Russ was ten years old, he was discovered by Lloyd Bridges and cast in a play called *Stone Jungle*. This launched Russ on a career in motion pictures, television, and theater that spanned the next four decades.

His first motion picture was *The Boy with Green Hair*. His performance in *Retreat Hell* won him a long-term contract with MGM studios. While there, he starred in the musical *Seven Brides for Seven Brothers*. He received an Academy Award nomination for Best Supporting Actor in the film *Peyton Place* and went on to star in such films as *Tom Thumb*, *The Haunting*, and *West Side Story*.

In 1964, Russ shifted from the performing arts to the fine arts. His work brought him recognition in numerous gallery exhibitions including the Los Angeles Institute of Contemporary Art. His art and poetry can be found in many international art publications.

He has continued to appear on stage in such musicals as *Bye Bye Birdie*, *Cabaret*, and *Follies*. In the early 1980s, he collaborated with long-time friends Neil Young, Dean Stockwell, and Dennis Hopper to create the rock-noir film, *Human Highway*. His television credits span from "The Ed Sullivan Show" to "Twin Peaks."

Russ lives in Santa Monica, California, with his wife, Bonnie, and daughter, Amber Rose.

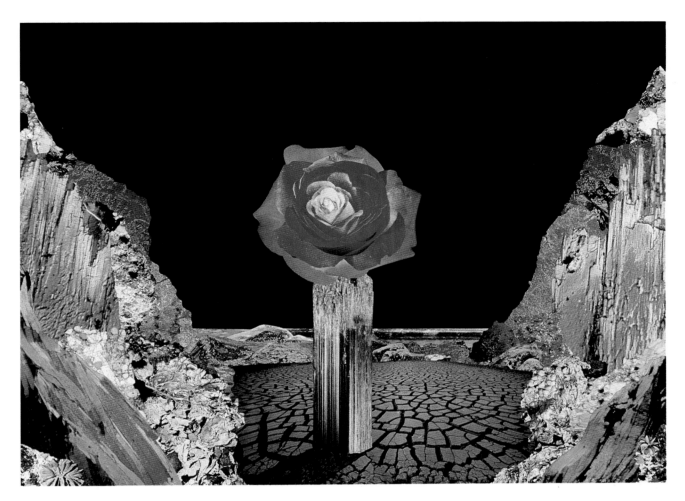

Amber Rose, 24" x 18", collage

I studied at the Chouinard Art Institute in 1955-56. A high school scholarship helped to finance my art education. I was inspired to paint by great teachers at North Hollywood High School and by my Aunt Fay, a fashion illustrator in Oklahoma City.

The only thought I have about the connection about acting and my work in the visual arts is that creating is fun. I can't get enough of painting.

Artists who have influenced my work are Wyeth, Manet, Degas, Neiman, Winslow Homer, and Rembrandt.

I paint for myself, not for others. Two years ago, after not painting for about twenty-seven years, my fiancée, Mia Melendez, encouraged me to get back into art and I did. A whole new beautiful world reopened for me.

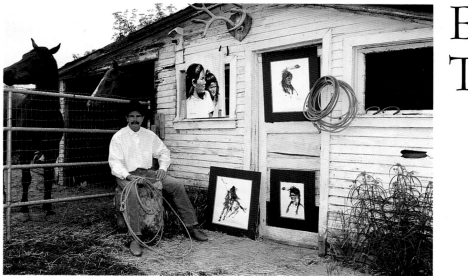

Buck Taylor

Buck Taylor has starred in hundreds of television shows, movies, and commercials.

Among the television shows he has appeared on are "The Sacketts," "Dallas," "Knot's Landing," "Simon and Simon," and, most recently, "Conagher." He is best remembered for his portrayal of Newly O'Brian on "Gunsmoke," a role he played for eight seasons.

His movies include *St. Valentine's Day Massacre*, *Legend of the Lone Ranger*, *Ensign Pulver*, and *Cathie Annie and Little Britches*.

His hobbies are hunting, fishing, steer roping, and marathon running. He also participates in many charitable events.

He is well known for his watercolor paintings and photography.

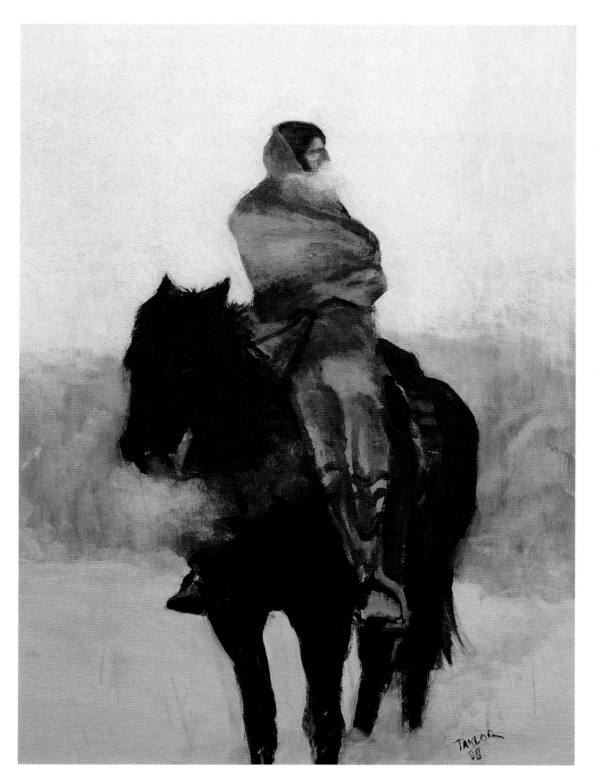

Yellowstone Winter, 20" x 24", acrylic

Rod Taylor

To put what you see on paper is the same as funneling what you feel through yourself as a performer. When I am working like hell as an actor, I paint. Acting doesn't suffice. Art doesn't feed me or fill the void when I am not working. If I haven't worked for six months I can't paint.

Light intrigues me. I experiment all the time. You can't look at one of my paintings and say "That's a Rod Taylor."

I wouldn't dream of selling my work. I give them to friends, to charities.

I've never grown up. It's my toy.

If you hear an actor whistle out of tune badly, he's probably not a very good actor. I think the same holds true of art.

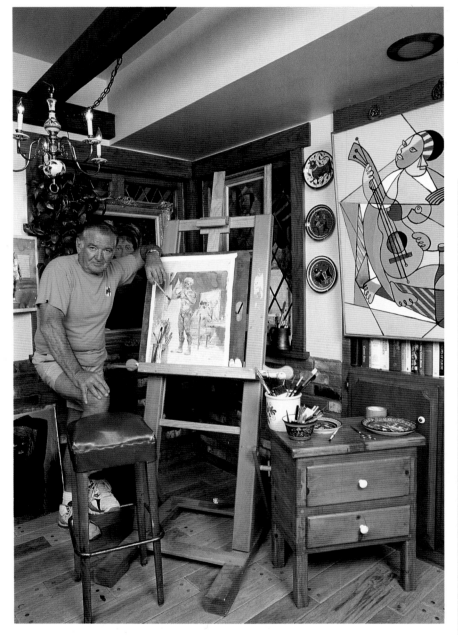

An American citizen for some years now, Australian-born actor Rod Taylor arrived in Hollywood in 1954 after beginning his career in his native country. He brought with him several awards for best actor.

MGM studios signed him to a long-term contract. He was featured in three pictures: *The Catered Affair*, starring Bette Davis, *Raintree County*, with Elizabeth Taylor and Montgomery Clift, and *Ask Any Girl*, opposite Shirley MacLaine. The studio began to star Taylor in a long list of films beginning with the H.G. Wells science fiction classic, *The Time Machine*.

In 1961 he was voted best new male personality and received a Golden Globe award. The following year Alfred Hitchcock starred him in *The Birds*. In 1963, John Ford gave Taylor the leading role in Sean O'Casey's *Young Cassidy*, with Maggie Smith and Julie Christie.

Taylor has headlined in five television series: "Hong Kong," "The Bearcats," "The Oregon Trail," "Masquerade," and "Outlaws."

Rod and his wife Carol live in Beverly Hills and Palm Springs, California. They have a daughter, Felicia.

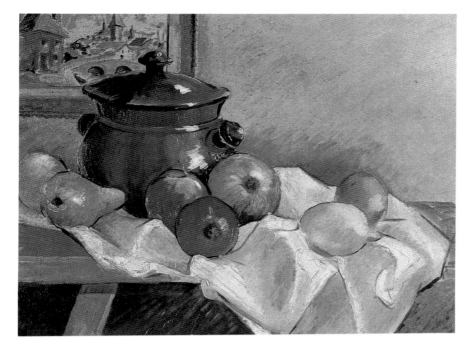

Still Life, 22" x 17", oil

Girl with a Jar, 13" x 17", oil

Growing up, I watched my mother, who was a schooled fine artist, paint one realistic painting after another. When I tried to paint, I became increasingly frustrated with my attempts to make things look real. My still lifes and portraits were, in my opinion, dismal failures.

It was only after I saw a collection of primitive paintings by American artist Streeter Blair that I began to think I could be a painter after all. As I studied the colors and the composition of his works I remember thinking, "I can do that!" It was positively enlightening to realize that there are no rules in primitive paintings. No perspective is necessary. No one is telling you the "right" and "wrong" way to paint.

Kristin Nelson Tinker

My first painting was a going-away gift to my family. I was seventeen and I was leaving to get married. My first one-woman show followed soon after.

I have exhibited my work in New York, Detroit, Santa Fe, Los Angeles, Orange County, and Washington, D.C.

I have painted now for almost twenty-six years. My work comes from reality, from dreams, from the way I always hoped it would be, from hopes for the future. They are statements of my thoughts at the moment and usually contain a secret or two.

I am presently working on a book of my own with stories to accompany my paintings.

Kristin Nelson Tinker was born and educated in Los Angeles, California. She studied art at the Otis Art Institute, married at the age of seventeen, and went back to study at UCLA.

From 1962 through 1966 she was a regular on the TV series, "The Adventures of Ozzie and Harriet" and "Adam 12." She has danced in various stage productions of *Carousel* and *The Sound of Music* and was a principal dancer in the Ballet Society of Los Angeles. She has made several feature films and is most proud of being in the Oscar-winning short film, *The Resurrection of Bronco Billy.*

As an American primitive painter, Ms. Tinker has been collected and exhibited since the age of seventeen when, inspired by the death of President John F. Kennedy, she was moved to express her feelings in the painting, *When the Kennedys Were in the White House.* This work led to a showing at the Sari Heller Gallery in Los Angeles and national recognition.

She and her husband Mark divide their time between the east and west coasts and the New Mexican plains. They have four children.

Miracle,
26" x 34", oil

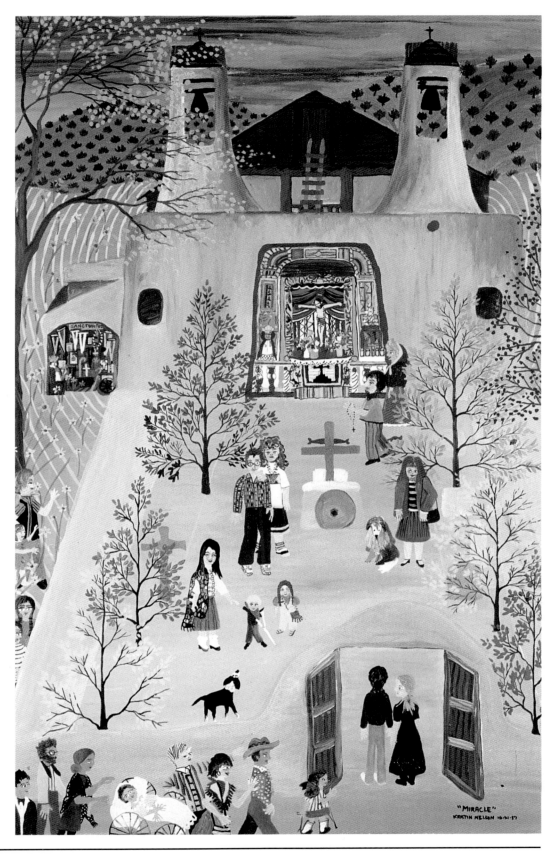

I think all the arts are akin. If you're artistic in one field you will be in another.

I started going to drawing class in 1953 at Lillian Alperson's house.

Claire Trevor

She was a producer who started having people come to her house for a drawing class. We used live models. Then it turned into a social thing. I was on fire with it. I wanted to get into color so I joined an art class with a Japanese teacher. I went twice a week for a year. We used live models and did still lifes.

I used to get a lot of satisfaction out of painting but not anymore. The world has taken such a crazy turn, a crazy careening pace and direction. I don't like the way the world is going. I don't like the way art is going. It's full of violence and horror. I love beauty too much to get excited about a gruesome painting.

I realized that I was doing nothing new in painting. I was only doing realistic portraits. It's too hard to paint spasmodically. I need to know that I have three days clear to do my work and to do that it means I have to cut off my friends. I'd have to become a recluse to paint.

My painting has suffered because of that need. I'm a special animal. I need to be with people.

Gifted means one thing: the ability to work hard, to buckle down. It's tenacity. Someone said (I'm not sure who) that it's ninety percent perspiration and ten percent inspiration.

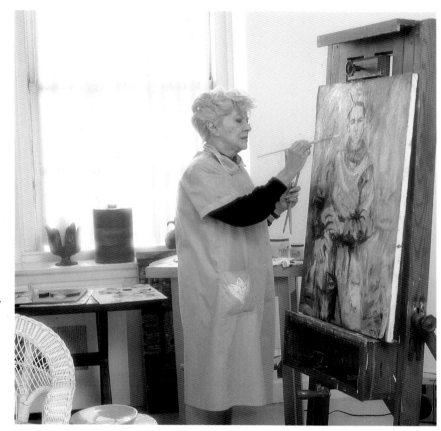

Claire Trevor started her career on the stage. After several lean years, she won stardom in films. Some of her movies include *Life in the Raw, Dante's Inferno, The Amazing Dr. Clitterhouse, Stagecoach, Murder My Sweet, Johnny Angel, The High and the Mighty, Marjorie Morningstar,* and *Two Weeks in Another Town.*

She won an Academy Award for Best Supporting Actress for her performance in *Key Largo,* a 1948 film directed by John Huston. *Largo* also starred Humphrey Bogart, Lauren Bacall, Edward G. Robinson, and Lionel Barrymore.

Tyrone Power, 36" x 48", oil

Vanity

Every time I move, I have to deal with another color spectrum. When I was a kid I dealt with black and white. The world is not just black and white. I know that there are grey carpets and green iguanas, but I love the starkness and dramatic quality of black and white.

When I was in school I always wondered why the other kids never put clothes on their stick people. I was very proper.

I'm stuck in the dark ages. Most of the things I do I've seen before in a past life. I get such ecstasy that it's like there's a beautiful spirit there in the room with me. Every move I make is really the spirit guiding me, helping to shape the work.

I believe that art comes through you. I have an old soul. Other psychics tell me to get out of the seventeenth century.

Vanity was raised in Niagara Falls, Ontario, by her father and stepmother. She was always the creative eccentric, chasing a dream. At seventeen she moved to Toronto to pursue a modeling career and was hired by Pearl Drops Tooth Polish to sell their product. This was followed by more work in commercials and roles in Canadian films, including one with the then unknown actress Jamie Lee Curtis.

Vanity's career began to develop after she met rock star Prince backstage at an awards show in Los Angeles. He helped her to form Vanity 6, a funky girl trio that produced a hit single record, "Nasty Girls," and an album that featured songs written by Vanity. The album reached gold status. Her second Motown album, *Skin on Skin*, featured nine songs written especially for her.

In movies, she has co-starred with Roy Scheider and Ann-Margret in *52 Pickup* and with Carl Weathers in *Action Jackson*.

Spot Dick, 27" x 36", ink

Cornel Wilde

I've always enjoyed risk. Acting, painting, fencing—it all includes an element of risk.

When I studied art we were trained in watercolors. We could only use one color and white in order to help stretch our abilities in tonality.

After finishing a film called The Naked Prey, *I decided to create a painting about the movie. It showed the warriors on the brow of a hill in silhouette. We didn't have an antelope and I didn't want to kill anything so I had the prop man cut an antelope out of wood. The tail was fake so it could swing freely and look like fresh meat. I felt that my painting embodied the spirit of the film.*

The same sense of composition I learned from painting was automatically transferred into film directing. That eye, that choice of where to put the camera, is very closely related to how you approach a painting.

Art has been my constant companion and my friend ever since I was a small boy and my father encouraged me to pick up a brush.

Cornel Wilde was a respected actor, champion fencer, writer, director, and producer. His films include *Lady with Red Hair, Kisses for Breakfast, Wintertime, High Sierra, Life Begins at 8:30, A Song to Remember* (in which he played Chopin), *Leave Her to Heaven, The Bandit of Sherwood Forest, Forever Amber, Roadhouse, The Greatest Show on Earth, Woman's World,* and *Omar Khayyam.*

He wrote, directed, and starred in *Beach Red* and *The Naked Prey.* Cornel Wilde passed away on October 16, 1989.

Naked Prey, 30" x 20", oil

Billy Dee Williams

I've been painting for as long as I can remember. The ability was always there.

Many years ago I met a guy named Charlie Ellis, who was married to Edna St. Vincent Millay's sister. He said to me, "Billy, you should try to make as much money as you can and buy yourself a wonderful little cottage somewhere in the country and just paint." And that's something that has always been in the back of my mind—one of those things you just file away.

I'm a peaceful man. I want to be surrounded by peaceful things, peaceful people, and art. I was raised with the idea that art had a very special meaning. It expresses all the machinations, the metaphors, and the allegories of life. It's also fun.

I paint for a lot of reasons. I don't know if it's therapeutic for me because when I'm trying to arrive at some particular point, I go through a lot of pain. It's like trying to develop an act or create a character.

I don't think there's much difference between acting and art except that you're using different mediums. It's all about research, shaping, forming, and putting something together so that it creates some sort of impact.

The wonderful thing about painting is that it's a solitary thing. You don't have to rely on a whole lot of people to come up with a point of view. It's your point of view.

I work fast. It's pure enthusiasm—a need to get out there and do it.

I get my ideas from everywhere. I collect things—articles, photographs—that I use for reference.

Why did I get into acting? I started when I was a kid. I did extra work on television so I could buy canvas and paints.

The Homeless, 48" X 60", acrylic

Billy Dee Williams was born in New York City. He made his Broadway debut at the age of seven in the short-lived musical, *The Firebrand of Florence*. He attended the High School of Music and Art and later won a scholarship to the National Academy of Design for the Fine Arts. For his paintings, he won the Guggenheim and Halgarten awards.

Williams attended the Actor's Workshop in New York. He attracted the attention of critics and audiences when he appeared on Broadway in *The Cool World*. He received more attention when he appeared with Angela Lansbury in *A Taste of Honey* and opposite Leslie Uggams in *Hallelujah Baby*. In 1988 Billy Dee returned to Broadway in the Tony award-winning play *Fences*.

The first major milestone in his career was his portrayal of Gale Sayers in the TV movie *Brian's Song*, for which he received an Emmy nomination.

Following *Brian's Song*, he appeared opposite Diana Ross in *Lady Sings the Blues* and *Mahogany*. These films catapulted him to star status. Since then he has appeared in such films as *Batman*, *The Empire Strikes Back*, *Return of the Jedi*, and *Giant Steps*.

He and his wife Teruko live in California and share their home with their children.

Marie Windsor

It is my belief that actors have more of an innate ability to bring out their creativeness in many directions because they have been conditioned by their craft to express themselves more freely than the average person. It would seem a natural course that actors need alternate artistic outlets. I have found expression in other art areas has a tremendous calming effect, giving me time for meditation and helping me to bring my emotions into focus. Such diversions are especially beneficial in the life of an actor, whose profession is often precarious. More often than not the work is sporadic and the lack of it can be heartbreaking.

When I was eight years old I decided I wanted to be an actress. At the same time I discovered drawing gave me great pleasure. Many years later, when I entered Brigham Young University, my intention was to obtain two majors—one in drama and the other in art. During my two years there I took many classes in both. When I decided to give up the college life to go to the Maria Ouspenskaya School of Drama in Hollywood, I always managed to find an art school or class to attend.

I now have my own little studio and kiln behind our house where I can paint, do my enamel work, work with papier-mâché, or sculpt. There are many directions in which I can direct my creativity. I feel most fortunate to have the space, equipment, and supplies where I can thrust myself into various forms of art. This space is not for the outside world; it's just for me. The work involved in creating something is often more rewarding than the results.

Marie Windsor's stage career began when she was a student at Brigham Young University. On California stages she has appeared in numerous productions and received the Los Angeles Critics award for her work in *The Bar off Melrose*.

In 1983, in recognition of her work in over seventy motion pictures and numerous radio and television appearances, Ms. Windsor was honored by having her star placed on the Hollywood Walk of Fame. Among her many tributes have been *Look* magazine's Best Supporting Actress award for her performance in one of Stanley Kubrick's first films, *The Killing*, and the Golden Boot award from the Motion Picture and Television Fund in recognition for her contributions to Western films.

Ms. Windsor is involved in many charities and served on the Board of the Screen Actors Guild for twenty-five years.

Windsor Prince, 3" x 4", enamel on silver

Jonathan Winters

Art has and always will be one of my dearest "friends." It's like your eyes and ears. It's a collection of pictures you take with you wherever you go. It's a collection of paintings that belong to you for a lifetime.

When I was a youngster, I wanted to be a cartoonist. Later in life I changed my mind. I still feel that cartoons have a lot to say, both serious and funny. One of the biggest thrills in my life was selling a cartoon to the Saturday Evening Post.

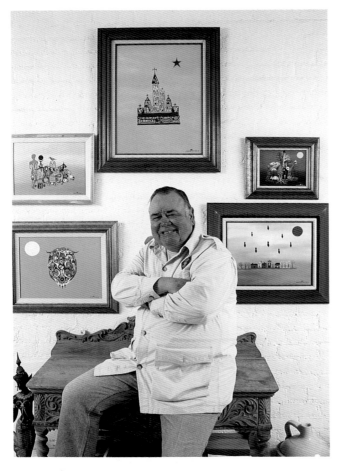

When I came out of the Marines, after World War II, I attended art school. My biggest problem at that time was finding a style, something that would allow me to be different from my fellow painters. A number of years later, after graduating from school, I found it. It was a cross between surrealism and primitive.

One of the most important facets of painting (especially to a rebel) is that you're in charge. You sink or swim with what you've painted. I encourage everyone who wants to paint to just do it—paint! Don't wait around for support, praise, or rejection. Just get to it. Don't tell me, "I can't draw a straight line." I know better.

Unless you're a pro, don't feel you have to paint every day. Paint when you feel like it, but stay with it until you've finished what you started.

There's a whole world of ideas out there. When, through your eyes and mind, your ideas are transferred to the canvas, they become that unusual painting or paintings that people are looking for.

Jonathan Winters was born in Dayton, Ohio. After two-and-a-half years in the South Pacific with the Marines, he returned to Springfield where he attended college and the Dayton Art Institute.

His wife, Eileen, persuaded him to become a professional entertainer. Local talent contests led to an early morning disc jockey job on WING in Dayton. Then he headed for New York where he appeared at Manhattan's Blue Angel, was presented by Jack Paar on his early-morning talk show, and appeared frequently on the Garry Moore and Steve Allen shows. When Jack Paar took over "The Tonight Show," Winters became a top name in American comedy.

Other TV appearances have included "Mork and Mindy," in which he played Robin Williams's son, "The Wacky World of Jonathan Winters," and his current series, "Davis Rules."

His first film was Stanley Kramer's *It's a Mad, Mad, Mad, Mad World.* He has also appeared in *Oh Dad, Poor Dad, The Loved One*, and *The Russians Are Coming, The Russians Are Coming.*

Winters has written two books: *Winters' Tales* and *Hang-Ups: Paintings by Jonathan Winters.*

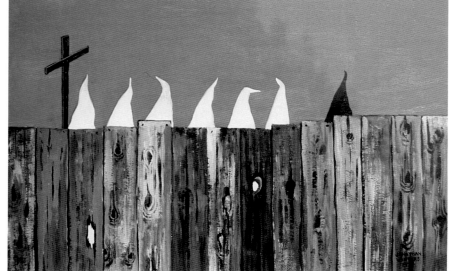

A New Member, 24" x 18", acrylic

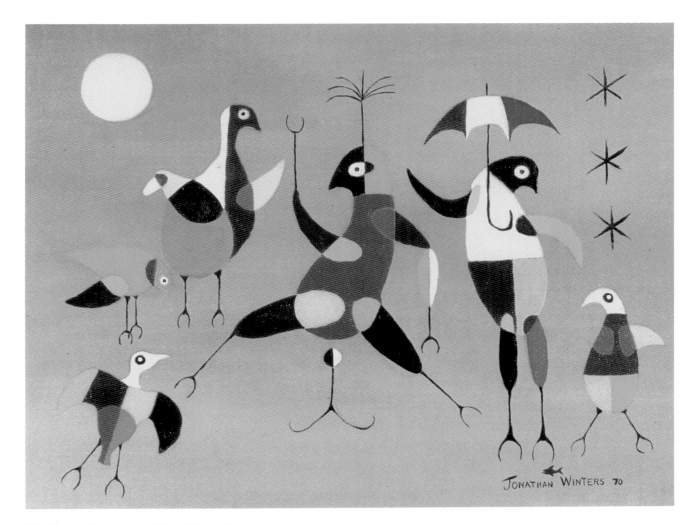

The Umbrella Dancers, 12" x 9", acrylic

Mary Woronov

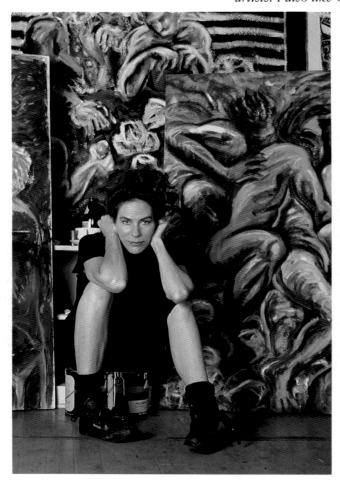

I started very, very young. I was given crayons to shut me up. By the time I went to college, art was the thing that stuck out the most. I went to Cornell as a sculpture major. When I got out of art school I was so depressed I sort of stopped and that's when I started with Warhol.

My favorite painters are Max Beckman and some of the new German artists. I also like Clemente and I am probably the only one in the world who likes Schnabel. I have been influenced by a good friend of mine, Susan Rothenberg. We met at Cornell. I don't think her paintings are anything like her.

Painting is a major form of expression for me. I cannot stop doing it. The closest I came to not doing it was when I started acting for Warhol right after Cornell. I didn't like my schooling and it made me stop.

I am not a pop artist, but Warhol has influenced my work. He had a tendency to destroy set ideas. Out of destruction comes life. In other words, if he saw something all set up he'd do the opposite to make it chaotic. I used that concept in my art.

The point of a painting is that you look at it and you get everything at once in that instant. It's not a movie—there aren't more pictures to come. It's all right there. It's like a window that just sort of transcends into something that you can't explain.

Everybody asks me, which do you like better, acting or art? That's like asking me whether I like my right hand or my left hand. I've always done both—acting and art. In acting it's a combination of many people— the director, the lighting man, other actors, and ideas. With art there is no conglomeration. It's just me. I have full control. If I didn't have art I would probably be trying to direct or do something else to gain more control.

Painting is lonely. Acting is not. They balance out.

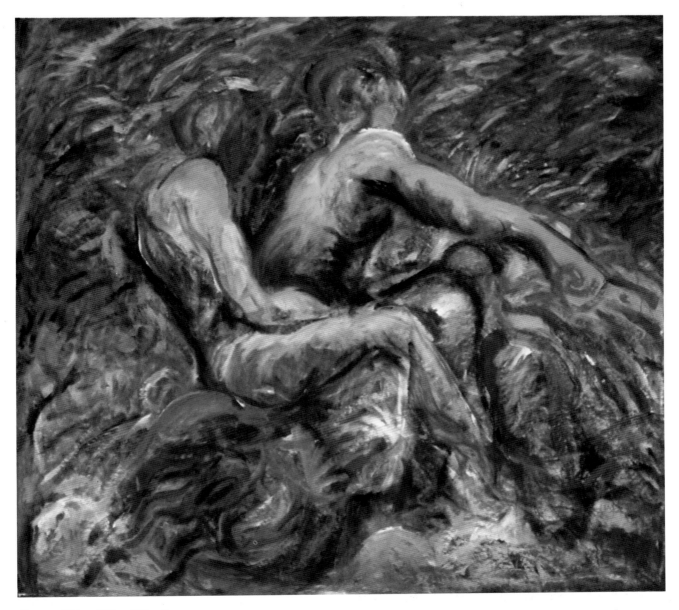

Uneasy Rider, 58" x 58", oil on canvas

Mary Woronov's career in films began by accident when, in 1964, the recently graduated Cornell University sculptor drifted into New York's circle of artists, musicians, and poets that became internationally known as Andy Warhol's Factory. When Warhol began dabbling in film, Woronov became one of his stars. After her debut in *Screen Test*, she went on to appear in such Warhol experiments as *The Beard*, *Hedy Lamarr*, *Milk*, and *Chelsea Girls*.

After touring with Warhol and the Velvet Underground, Woronov left the Factory to expand her career. She soon earned the lead role in David Rabe's *In the Boom Boom Room*, winning the 1974 Theater World Award for her performance.

In Hollywood, Woronov became a member of producer Roger Corman's company, appearing in a number of his films including *Hollywood Boulevard* and *Rock 'n' Roll High School*.

Woronov's big break in movies came when she starred in *Eating Raoul*, the sleeper hit of 1982.

In the last few years Woronov has spent much of her time painting. She has had showings at galleries across the country.

Credits and Acknowledgments

Bettye Ackerman: photograph of Bettye Ackerman © by Ralph Merlino/Shooting Star. Art, collection of Bettye Ackerman.

Steve Allen: photographs © by Ralph Merlino/Shooting Star.

Tige Andrews: photograph of Tige Andrews © by Ralph Merlino/Shooting Star.

Michael Ansara: photograph of Michael Ansara © by Ralph Merlino/Shooting Star.

Lew Ayres: photograph of Lew Ayres © by Ralph Merlino/Shooting Star. Photograph of art by Louis Zweier.

Lionel Barrymore: etching and permission from the collection of Eleanore Phillips Colt. Text on art is from *We Barrymores* by Lionel Barrymore as told to Cameron Shipp, Appleton-Century-Crofts, New York, 1951.

Noah Beery: photograph of Noah Beery © by Ralph Merlino/Shooting Star. Photo of bronze by Louis Zweier.

Ralph Bellamy: photograph of Ralph Bellamy by Wayne Williams/Shooting Star. Art, collection of of Ralph Bellamy.

Candice Bergen: photograph of Candice Bergen by Greg Gorman. Art, collection of The Franklin Mint.

Richard Beymer: photograph of Richard Beymer © by Ralph Merlino/Shooting Star.

David Bowie: photograph of David Bowie by Mary Hilliard.

Pierce Brosnan: photographs © by Ralph Merlino/Shooting Star.

James Cagney: photograph of James Cagney by Diernhammer/Shooting Star. Art, collection of Ralph Bellamy. Text on art from *Cagney By Cagney*, Doubleday, New York, 1976.

Barbara Carrera: photographs © by Ralph Merlino/Shooting Star.

Robert Clary: photograph of Robert Clary © by Ralph Merlino/Shooting Star.

Claudette Colbert: photograph of Claudette Colbert by Michael Teague.

Gary Conway: photograph of Gary Conway © by Ralph Merlino/Shooting Star.

Hazel Court: photograph of Hazel Court © by Ralph Merlino/Shooting Star. Photo of art by Conrad Johnson.

Phyllis Diller: photograph of Phyllis Diller © by Ralph Merlino/Shooting Star.

Dennis Dugan: photograph of Dennis Dugan © by Ralph Merlino/Shooting Star.

John Ericson: photograph of John Ericson © by Ralph Merlino/Shooting Star.

Peter Falk: photograph of Peter Falk © by Ralph Merlino/Shooting Star. Photograph of charcoal drawing of woman with jacket © by Ralph Merlino/Shooting Star. Photograph of "Self Portrait" by Yoram Kahana/Shooting Star.

Henry Fonda: photograph of Henry Fonda by Peter Kredenser/Shooting Star. Photo of art and text on art are courtesy of The Franklin Mint and are from their video production "The Celebrity Art Portfolio."

John Forsythe: photograph of John Forsythe by S. Murphy/Shooting Star.

Dick Gautier: photograph of Dick Gautier © by Ralph Merlino/Shooting Star.

Bruce Glover: photograph of Bruce Glover © by Ralph Merlino/Shooting Star.

Cliff Gorman: photograph of Cliff Gorman by Steven Begleiter. All rights reserved.

Coleen Gray: photograph of Coleen Gray © by Ralph Merlino/Shooting Star.

Gene Hackman: photograph of Gene Hackman by Chas Gerretsen.

Jerry Hardin: photographs by Hal Smith.

Bo Hopkins: photograph of Bo Hopkins © by Ralph Merlino/Shooting Star.

John Huston: photograph of John Huston collection of Henry B. Hyde. Art, collection of Bettye Ackerman.

Anthony James: photograph of Anthony James © by Ralph Merlino/Shooting Star.

Anne Jeffreys: photograph of Anne Jeffreys © by Ralph Merlino/Shooting Star.

Van Johnson: photographs by Martha Swope.

Steve Kanaly: photograph of Steve Kanaly by M. Marrow/Shooting Star.

Sally Kirkland: photograph of Sally Kirkland © by Ralph Merlino/Shooting Star.

Piper Laurie: photograph of Piper Laurie © by Ralph Merlino/Shooting Star. Photograph of art by Ariel Borremans.

George Maharis: photograph of George Maharis © by Ralph Merlino/Shooting Star.

Leigh McCloskey: photograph of Leigh McCloskey © by Ralph Merlino/Shooting Star. Photograph of art by Ronn Moss.

Doug McClure: photograph of Doug McClure © by Ralph Merlino/Shooting Star. Photograph of art by Gene Trindle.

Jim McMullan: photograph of Jim McMullan © by Ralph Merlino/Shooting Star. Photograph of "Road Kill" © by Ralph Merlino/Shooting Star. Photograph of "D'Light Series #9" by Hal Smith.

George Montgomery: photograph of George Montgomery © by Ralph Merlino/Shooting Star. Photograph of art by Herb Ball.

Michael Moriarity: photograph of Michael Moriarity by Steven Begleiter. All rights reserved.

Zero Mostel: photograph of Zero Mostel by Mal Warshaw. "Self Portrait" collection of Bettye Ackerman.

Martin Mull: photograph of Martin Mull © by Ralph Merlino/Shooting Star. Art, collection of Jay Daniels.

Kim Novak: photograph of Kim Novak by Tom O'Neal/TGO. Photograph of art by Lee Hocker.

Jeff Osterhage: photograph of Jeff Osterhage © by Ralph Merlino/Shooting Star.

Jack Palance: photographs © by Ralph Merlino/Shooting Star.

Slim Pickens: photograph of Slim Pickens by Charles Moore.

Eve Plumb: photograph of Eve Plumb by M. Marrow/Shooting Star.

Anthony Quinn: photograph of Anthony Quinn by Jean-Claude Francolon of Gamma Paris.

Tommy Rall: photograph of Tommy Rall © by Ralph Merlino/Shooting Star.

Robert Redford: photograph of Robert Redford by John Schaefer.

Duncan Regehr: photographs © by Ralph Merlino/Shooting Star.

Burt Reynolds: photograph of Burt Reynolds by Lisa Smith.

Madlyn Rhue: photograph of Madlyn Rhue by Harry Langdon. Photograph of art by Louis Zweier.

Peter Mark Richman: photograph of Peter Mark Richman © by Ralph Merlino/Shooting Star.

Edward G. Robinson: photograph of Edward G. Robinson, by Elmer Fryer, courtesy of Francesca Robinson Sanchez and Warner Brothers. Art, collection of Bettye Ackerman. Text on art from *All My Yesterdays: An Autobiography of Edward G. Robinson*, Hawthorne Books, New York 1973.

Franklyn Seales: photograph of Franklyn Seales courtesy of his estate.

Jane Seymour: photographs by Peter Kredenser.

Robert Shields: photograph of Robert Shields by Will Mosgrove.

Dinah Shore: photograph of Dinah Shore © by Ralph Merlino/Shooting Star.

Elke Sommer: photograph of Elke Sommer © by Ralph Merlino/Shooting Star.

Sally Struthers: photograph of Sally Struthers by Mario Casilli.

Russ Tamblyn: photograph of Russ Tamblyn by M. Marrow/Shooting Star.

Buck Taylor: photograph of Buck Taylor © by Ralph Merlino/Shooting Star.

Rod Taylor: photograph of Rod Taylor © by Ralph Merlino/Shooting Star.

Kristin Nelson Tinker: photograph of Kristin Nelson Tinker © by Ralph Merlino/Shooting Star. Photograph of art by Tony Cunha.

Claire Trevor: photograph of Claire Trevor by Steven Begleiter. All rights reserved. Art, collection of Deborah Power Loew.

Vanity: photograph of Vanity © by Ralph Merlino/Shooting Star.

Cornel Wilde: photograph of Cornel Wilde by Dan Golden/Shooting Star.

Billy Dee Williams: photograph of Billy Dee Williams by M. Marrow/Shooting Star.

Marie Windsor: photographs © by Ralph Merlino/Shooting Star.

Jonathan Winters: photograph of Jonathan Winters © by Ralph Merlino/Shooting Star. Art courtesy of Random House Publishers.

Mary Woronov: photograph of Mary Woronov by Alisha Tamburri/Shooting Star.